IMAGES
of America

KINGS COUNTY

IMAGES
of America

KINGS COUNTY

Robin Michael Roberts

ARCADIA
PUBLISHING

Published by Arcadia Publishing
Charleston SC, Chicago IL, Portsmouth NH, San Francisco CA

Printed in the United States of America

Library of Congress Catalog Card Number: 2008920086

For all general information contact Arcadia Publishing at:
Telephone 843-853-2070
Fax 843-853-0044
E-mail sales@arcadiapublishing.com
For customer service and orders:
Toll-Free 1-888-313-2665

Visit us on the Internet at www.arcadiapublishing.com

CONTENTS

ACKNOWLEDGMENTS

A number of people provided invaluable assistance in gathering photographs or information that contributed materially to this book. As with my previous books, Kings County librarian Louise Hodges, Hanford branch librarian Gayle Lucas, and reference librarian Sherman Lee of the Kings County Library provided the bulk of the access and assistance.

JoAnn Gibbons, director of the Hanford Carnegie Museum, and docent David Vierra allowed me to spend many enjoyable and valuable hours of research among the museum files. My friend Kerry Arroues, of the USDA Natural Resources Conservation Service, escorted me into portions of the county not accessible to the general public, and his intimate knowledge of the geography of the county was of immense value. He also made available thousands of photographs that had not previously been made public.

Lemoore branch librarian Christine Baize and her staff were courteous and helpful is making available their collection of Lemoore photographs and Lemoore High School yearbooks.

Likewise, Lemoore High School office manager Phyllis Machado and Lemoore High School athletic director Thom Sembritski allowed me entrance to the Lemoore High School Hall of Fame during winter break. My longtime friend Lee Pritchard helped out on more than one occasion.

I am grateful to the historians of the past who recorded Kings County history in words or photographs. I particularly want to recognize the work of William B. Secrest Jr., whose editing of the classic Wallace Smith valley history *Garden of the Sun* materially improved the original, and Mark Arax and Rick Wartzman's research for their best-selling history of J. G. Boswell, *The King of California*, which provided invaluable information about Corcoran.

Finally, my editor John Poultney has been more than patient with me, an understanding that has no doubt deepened since he has finally authored an Images of America book of his own. Way to go, John!

INTRODUCTION

Kings County, California, was officially created on May 23, 1893, from portions of Tulare and Fresno Counties. On that date, an election to approve the measure authorizing the formation of the county was held among the voters of the proposed county. The final vote count was 1,412 for the measure against 412 opposed—mostly from Lemoore voters upset that Hanford was designated as the seat of the new county. The actual measure to create the county, entitled the Kings Division Act, was signed by then-Governor H. H. Markham on March 23, 1893.

The path to county-hood was not an easy one for the residents of what was then known as the Mussel Slough country, largely because Tulare County was reluctant to lose the rich agricultural wealth centered in that area. At the time of its formation, the area that became Kings County was one of the richest portions of Tulare County, and it was for precisely that reason that agitation for forming a separate county arose among the residents of the Mussel Slough country. Already identified as independent rebels by the titular reference to the famous Mussel Slough tragedy, many residents of the future Kings County disliked sending "their" money off to be spent by those in faraway Visalia.

The first attempts to form a new county came from Dr. A. B. Butler of Grangeville, who represented the area in the California Legislature. In 1886, he introduced a bill to form a new county from the western portion of Tulare County and selected adjacent portions of Fresno County. The two existing counties pooled their political resources and successfully lobbied to kill the measure. Dr. Butler was succeeded in the assembly by W. S. Cunningham of Lemoore, who introduced a similar bill that was also defeated.

It was not until the term of Hanford assemblyman Frank G. Blakely that circumstances were propitious for the successful creation of a new county in the Mussel Slough area. In early 1893, legislative efforts to create Madera County from portions of Fresno County and Riverside County from San Bernardino and San Diego Counties were likewise fighting their way through the legislative jungles of Sacramento. The Kings County effort was joined to those two, and the three-county coalition was able to carry the day.

The difficulties in forming the new county did not end with the successful voter endorsement of the measure for creation. Tulare County challenged the Kings Division Act on constitutional grounds, being unwilling to relinquish their western cash cow. The office of the California attorney general found favorably for the new county and ruled that it was constitutional on June 19, 1893—and included similar decisions for Madera and Riverside Counties as well.

The residents of Mussel Slough might have had a new county, but they had no county resources—no money, no county courthouse or office, not even county stationery. Even the county name was not settled for sure. Several influential residents of the new county proposed the name Lorraine County instead of Kings, and a controversy over the county name raged for some time. Some Lemoore residents felt that the older, more established city of Lemoore rather than the new upstart Hanford should have been named the county seat. It was this situation that leaders of the new county faced that first summer of its existence. Temporary arrangements were made

to house county offices in various buildings around Hanford, and courthouse proceedings were held in several different locations around town. The new Kings County Board of Supervisors made a claim against Tulare County for their share of county funds, which they calculated as $14,655.58. Tulare County offered $13,289.16, which the new board, being desperate for working capital, accepted.

The board of supervisors purchased land for a county building from the local Presbyterian church for $16,000, an adjoining lot for $1,000 in gold coin, and a third lot from a civic-minded citizen for only $10. On May 13, 1896, John Haggerty was awarded the bid to construct a granite courthouse with terra-cotta trim for $26,364 to be paid for through the sale of bonds. The building was designed by W. H. Wilcox and completed in 1897.

What follows is a tale of Kings County that grows ever larger with each generation and that gains its power from the accumulated sacrifice and ingenuity of its citizenry. The present book is a companion to and continuation of the story begun in two previous books in the Images of America series: *Hanford* and *Hanford 1900–2000*. The text of *Kings County* makes reference to both books; please visit the associated web site: www.hanfordhistory.com.

One

KINGS COUNTY AND HANFORD

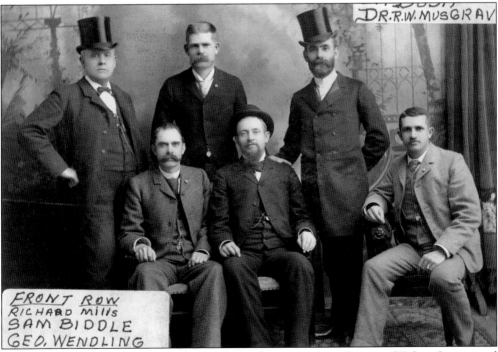

The leaders in the drive to split the Mussel Slough country from the rest of Tulare County and form a new county are in this 1892 photograph, from left to right, (first row) Richard Mills, Sam Biddle, and George Wendling; (second row) Tom Nolin, Edward Bush, and Dr. R. W. Musgrave. These men formed the Mussel Slough delegation to lobby in Sacramento in support of the creation of a new county. The California Legislature chose these men to be the commissioners in charge of the ratification election. (Courtesy Kings County Museum.)

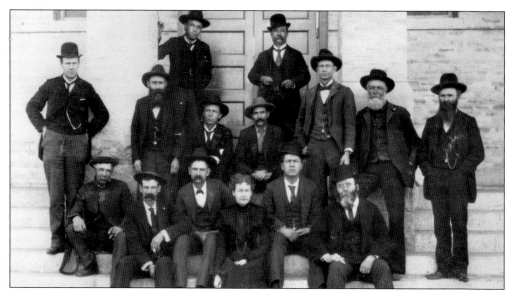

Among the early civic leaders in Kings County were the men and woman in this 1897 photograph. Included are Tom Dillon, county supervisor; John Irwin, attorney; Prof. J. W. Graham, school superintendent; Andy Ayers, deputy county sheriff; Frank Walker, county jailer; William Van Buckner, Kings County sheriff; Rowen Irwin, attorney; Howard McGinnis, constable; B. F. Goodrich, court reporter; M. L. Short, superior court judge; Frank Peacock, auditor-recorder; Francis Cunningham, county clerk; and the lone woman, Harriet McClung. (Photograph donated by Jane Ellen Bartholomew, courtesy Kings County Museum.)

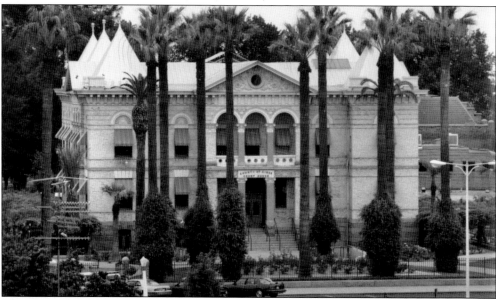

The site of the old Central School was chosen for the county offices and courthouse. Among the lots purchased to accommodate the structure was that of a Dr. Davidson, who had earlier planted the palm trees featured in this particular photograph. This building was constructed in 1897, expanded in 1914, and used as the center of county government until 1977. Today the remodeled structure houses numerous businesses and community organizations. (Courtesy Kings County Library.)

In addition to county offices and courtrooms, the new county needed a jail. This building opened in November 1898 and was conveniently adjacent to the courthouse. It served as the county jail until 1964, and after brief use as an art gallery, it became the Bastille restaurant in the 1980s. (Courtesy Kings County Library.)

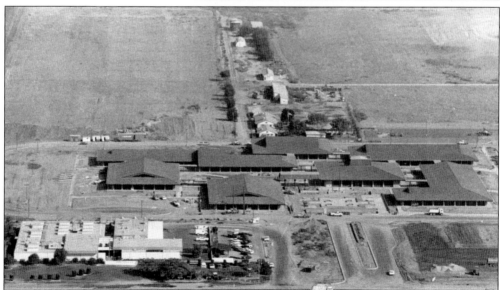

In 1977, the county offices and courts were moved to their present location on Lacey Boulevard. Known as the Kings County Government Center, it was completed as part of the bicentennial celebrations. (Courtesy Ruth Gomes Collection, Kings County Library.)

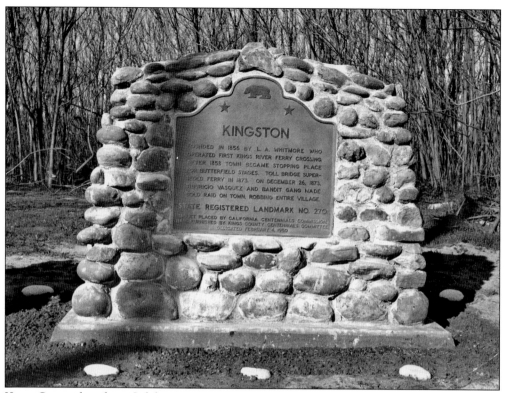

Kings County has three California State registered landmarks within its borders. All three were dedicated on February 4, 1950. Landmark No. 270, seen here, commemorates Kings County's first town, Kingston. For information about Kingston, see chapter three in Images of America: *Hanford*. (Courtesy Kings County Museum.)

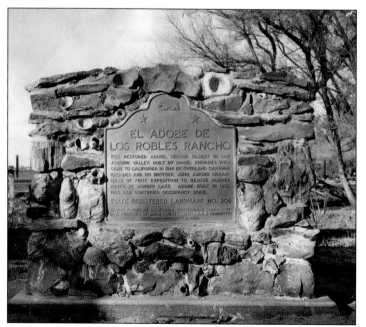

The second of the three California state markers commemorates Kings County's oldest continuously occupied structure and the second oldest permanent building known in the county. Built by Daniel Rhodes in 1857, it is still in use today. It is located at the southwest corner of State Highway 41 and Lacey Boulevard, just west of Lemoore. For more information, see pages 34 and 35 in Images of America: *Hanford* and page 35 in this book. (Courtesy Kings County Museum.)

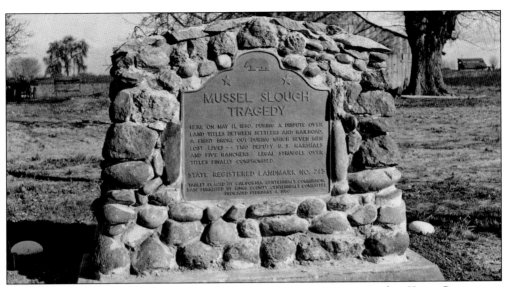

Perhaps the most renowned of the historical occurrences commemorated in Kings County was the infamous Mussel Slough tragedy. Like the other state historical markers, this marker was placed as part of the California Centennial celebrations. The marker wording contains some inaccuracies reflecting popular belief rather than historical fact. For more information, see chapter six in Images of America: *Hanford*. (Courtesy Kings County Museum.)

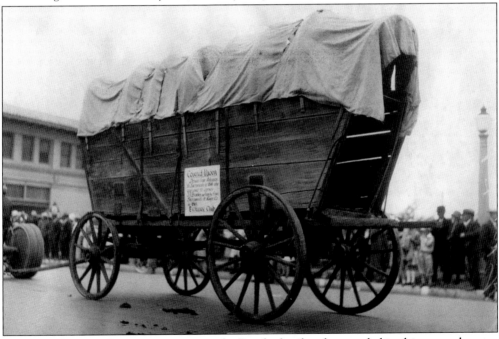

Among early Kings County pioneers was the Brooks family, who traveled in this covered wagon to Sacramento in 1849 and to Kings County in 1866. The wagon has long served as an unofficial Kings County symbol and was used in the annual homecoming parade until the early 1980s, when age and long use rendered it unsafe. The Kings County Museum at Burris Park Foundation and several county historical groups raised money to construct a replica of the wagon in the mid-1980s. (Courtesy Kings County Museum.)

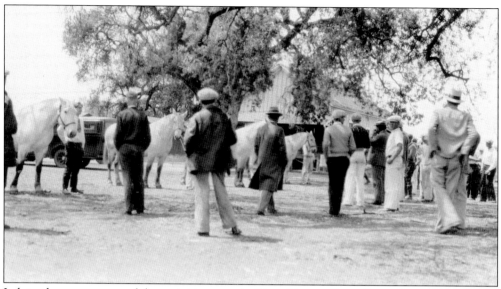

Judging horses was one of the activities at early Kings County Fairs. Kings County was known for its fine horses, including those raised by Ed Erlanger in Lemoore, Cuff Burrell in the Island District, and the Snyder family northeast of Hanford. In this 1920s-era photograph, Percheron horses are being judged. (Courtesy Kings County Library.)

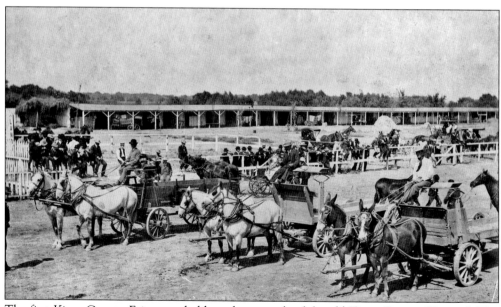

The first Kings County Fairs were held on the grounds of the old Kings County Hospital. The 1904 fair was in full swing when this photograph was taken. The fair moved to its own location several years later. The hospital likewise moved, and the Kings County Honor Farm, a low-security part of the prison system, was located on the site. (Courtesy Kings County Museum.)

In addition to parades in May celebrating the birth of the county and on the Fourth of July, an Armistice Day parade commemorating the end of World War I was held each year. In this November 11, 1928, photograph, members of the Exchange Club drive an antique spring wagon owned by Dr. Frank Griffith. The county jail can be seen in the background. (Courtesy Kings County Museum.)

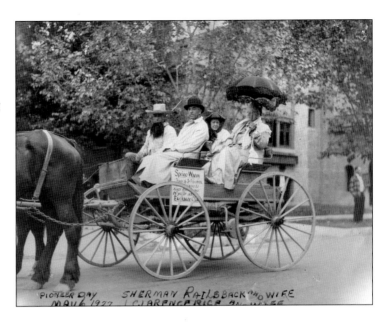

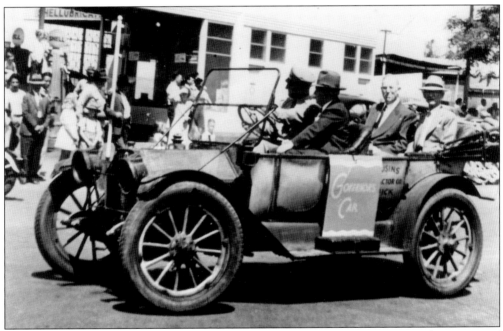

Kings County celebrates a Homecoming Days parade each May commemorating the creation of the county. The tradition dates to 1927, when a massive Pioneer Days parade kicked off a year of celebration. In 1946, Kings County district attorney Roger Walsh persuaded his longtime friend, California governor and later U.S. Supreme Court chief justice Earl Warren, to serve as grand marshal. Governor Warren sits in the rear seat of this car (on the left) owned by the Cousins Tractor Company next to pioneer Frank Pryor. Kings County sheriff Orvie Clyde rides shotgun. (Courtesy Kings County Library.)

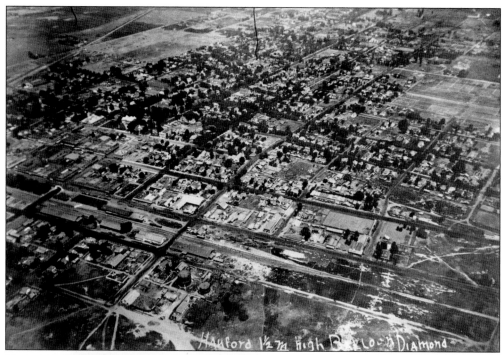

Hanford was chosen as the seat of Kings County. That fueled growth, and the town soon grew beyond the confines of its railroad-designed town site, as this 1910 photograph from a hot air balloon shows. Railroad-designed towns such as Hanford are sometimes called "T-towns" by historians, because the town typically develops in a t-shaped pattern parallel to the train tracks and along one or two perpendicular streets, usually to the north and east of the tracks. Hanford developed along Sixth and Seventh Streets parallel to the tracks and Harris and Irwin Streets perpendicular to the tracks. (Courtesy Kings County Museum.)

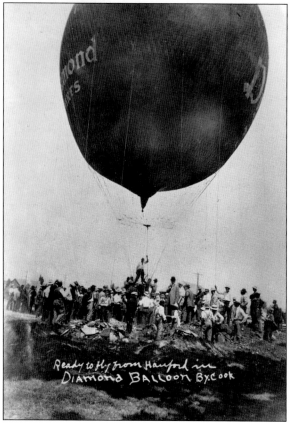

In 1910, the Diamond Balloon Company visited Hanford and provided balloon rides to numerous paying customers. The balloon was piloted by a man named Cook. (Courtesy Kings County Museum.)

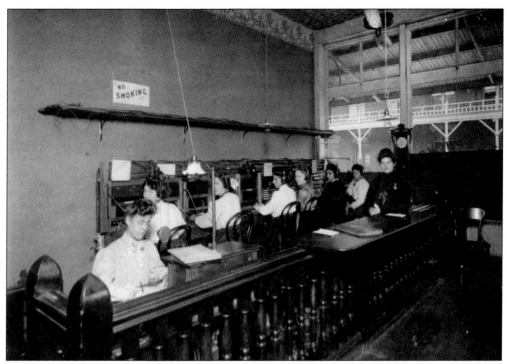

The Hanford Telephone Company Exchange is shown here in 1908. Among the operators are Kate Wallace, Cora Ogle, Elsie Willitt, Sibyl Farrar, Set Fisher, and Julie Leavitt. Some of the furniture from this office is now at the Kings County Museum at Burris Park. (Courtesy Kings County Museum.)

In February 1907, some of Kings County's earliest pioneers and leaders were photographed together. From left to right are Peter van Valer, James Robertshaw, James A. Hill, Horatio G. Lacey, and George Slight. (Courtesy Kings County Library.)

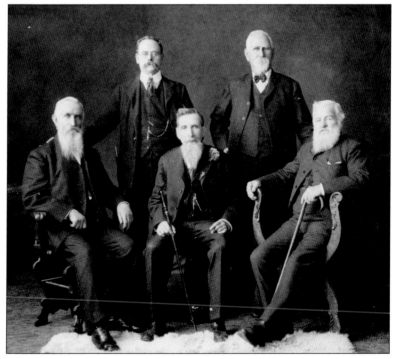

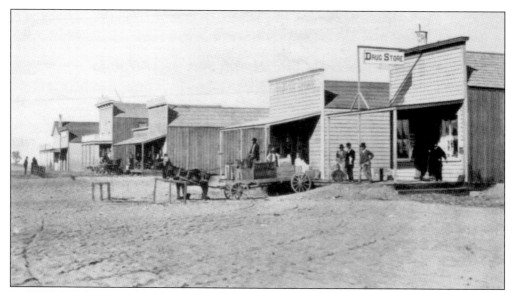

In 1877, J. T. Baker opened a drugstore on Sixth Street in the new town of Hanford, becoming one of the first stores in town. The store changed hands and locations over the years, eventually becoming Valley Rexall Drugs owned by Lee Pritchard. Until recently, it was the longest continuously operating business in the city and represented a direct tie to the founding of the town. (Courtesy Annie R. Mitchell Collection, Tulare County Museum.)

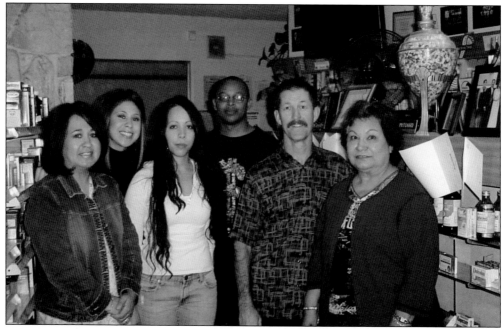

In January 2008, Lee Pritchard closed the doors of Valley Rexall and moved to Rite Aid. It marked the end of an era: no longer does Hanford have a business that has operated continuously for its entire lifetime. Shown from left to right are Kathy Rivera, Bree Rivera, Diana Infane Matthis, Milton Davis, Lee Pritchard, and Vernie McKelvey, whose husband, Charles, worked for Tomer's Drugs beginning in 1957. The old apothecary jar filled with pills has changed hands with the business for as long as anyone can remember. (Author's collection.)

This oak tree was marked in 1878 as the boundary between Fresno, Monterey, and Tulare Counties. In 1928, a dispute erupted between Fresno and Kings Counties over which was the location of the newly discovered North Dome, whose rich oil fields meant millions of dollars for county coffers. To resolve the dispute, Kings County surveyor Roy May followed the original survey field notes, beginning on the Kings River near Reedley. After reaching the approximate location, a survey marker was found. May directed Sid Doughtery, a member of the survey party, to pace off a certain number of feet in a given direction and drive a stake into the ground. Doughtery called back that he couldn't drive the stake in the ground because a large oak tree was in the way. Bark from the oak can be seen in the Burris Park Museum. (Courtesy Kings County Museum.)

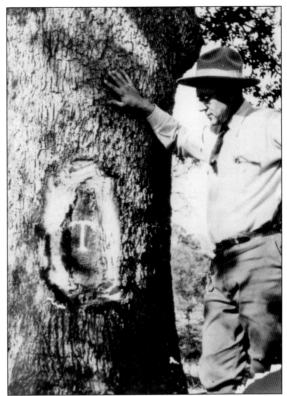

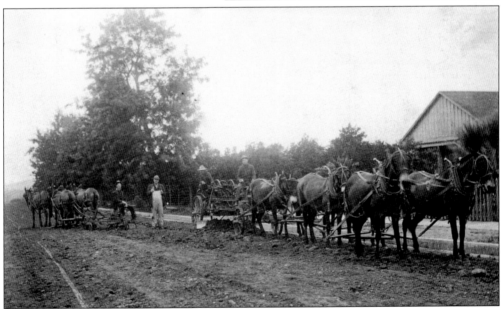

In 1915, Kings County residents voted to issue bonds for the construction of a series of county highways to connect major population areas. A photograph of the ground-breaking ceremony for the county road system appears on page 22 of Images of America: *Hanford 1900–2000*. In this photograph, workers can be seen grading dirt on Lacey Boulevard in preparation for paving as part of the county road system. (Courtesy Kings County Library.)

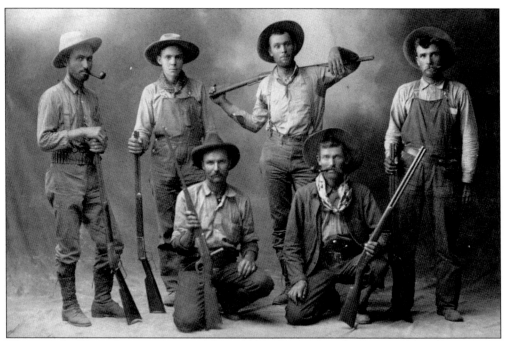

This isn't the Kings County version of the wild bunch, it is merely a group of deer hunters who stopped in Visalia on their way home from a 1910 hunt to get their picture taken. In the photograph are Wyn Drennen, Alfred Dennison, Jim Dunham, Arthur Dennison, Emmet Ford, and Uriah Welton in no particular order. For more about Emmett Ford, see page 95 in *Images of America: Hanford* and page 43 in *Hanford 1990–2000*. (Courtesy Kings County Library.)

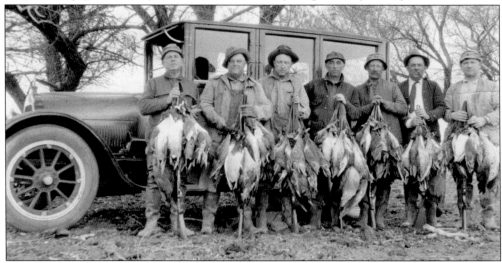

One didn't have to leave the county to enjoy a successful hunt. After a particularly successful duck hunt near Tulare Lake in December 1925, photographer Oral Claeu captured, from left to right, Bob Esrey, George Tiller, Jonathan McGlashan, Clarence Rice, Sandy McGlashan, Bob Kimole, and Professor Allen displaying their ducks. Such bags were common in the days when the lake was teaming with wildlife. Early residents tell of flocks so large they cast a shadow on the ground and all one had to do was point a gun in the air and pull the trigger. (Courtesy Ruth Gomes Collection, Kings County Library.)

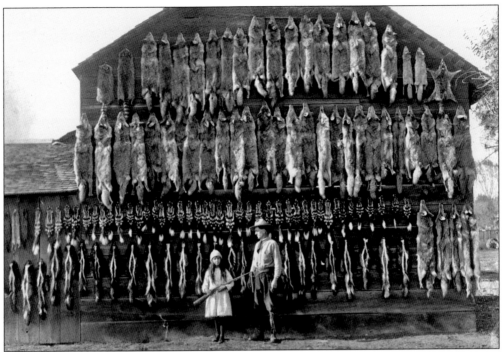

Not all hunting was for food or fun; some hunters were hired to eliminate pests, such as the then-ubiquitous coyote. "Sir Servador" Jack Barnett of nearby Kingsburg was hired to get rid of "Los Coyotes son diablitos." He is pictured here with his daughter on December 9, 1918, in front of a building located on Tenth Avenue near East Seventh Street. (Courtesy Kings County Library.)

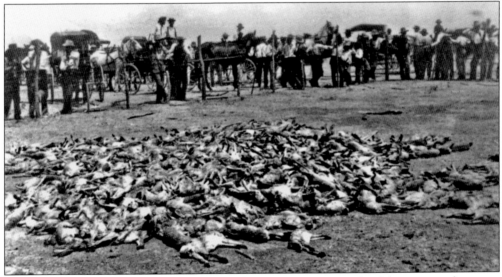

By 1897, thousands of rabbits were infesting the county, eating much of the grass used to graze stock. Residents would organize rabbit drives, a practice lasting until the early 1930s. They were conducted by dozens of hunters, armed with guns or clubs, who positioned themselves several hundred yards away from another group of participants, variously called chasers or beaters. The beaters would line up and begin walking abreast, driving the rabbits ahead of them toward the waiting hunters. (Courtesy Kings County Library.)

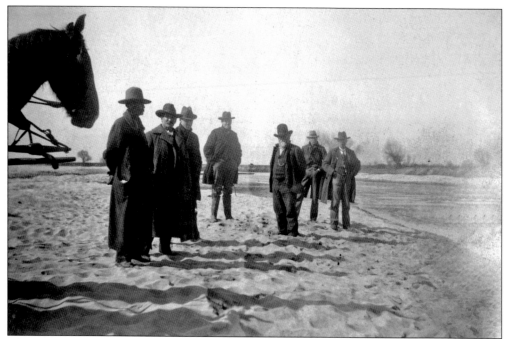

The Wild West was alive in Kings County in yesteryear. Photographed near the head of Dutch John's Cut around the end of the 19th century are, from left to right, A. B. Curtis, George Railsback, two unidentified, Cassius Blowers, E. D. J. Gibson, and G. E. "Dub" Shore. (Photograph donated by R. E. Shore, courtesy Kings County Museum.)

The Kings County Country Club near Laton, shown in 1930, still uses this building. Originally the ground floor of the first Hanford High School building, it was moved from the old school location at what is now Lacey Park after the high school moved to its present location. For related information about the old high school, see page 121 in Images of America: *Hanford*. (Courtesy Kings County Library.)

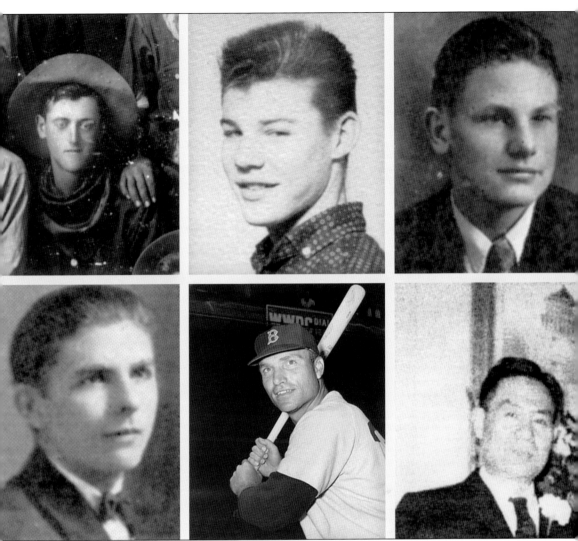

Among the more well-known Hanford residents are world-champion cowboy Cuff Burrell (top, left); future television and movie star Jan Michael Vincent (top, middle); legendary pole-vaulter Dutch Warmerdam (top, right); local photographer Ralph Powell Sr., who trained as a teenager under famed photographer Pop Laval (bottom, left); major-leaguer Bill Renna (bottom, middle); and world-renowned painter Henry Sugimoto (bottom, right). (Photograph composite by author from local sources, including Hanford High School yearbooks.)

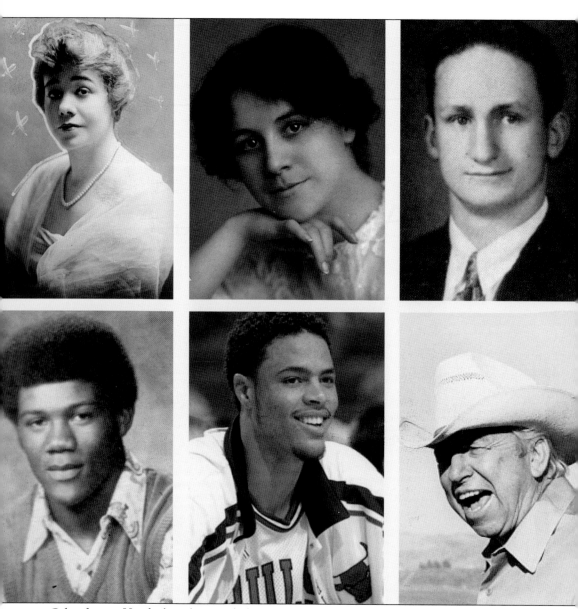

Other famous Hanford residents include actress Pauline Lord (top, left); actress Lillian Anderson (top, middle); Nobel Laureate James Rainwater, who worked on the Manhattan Project (top, right); NFL running back Jewrell Thomas (bottom, left); NBA star Tyson Chandler (bottom, middle); and movie character actor Slim Pickens (bottom, right). (Photograph composite by author from local sources, including Hanford High School yearbooks.)

Two

Lemoore,
NAS Lemoore,
Santa Rosa Rancheria,
and Stratford

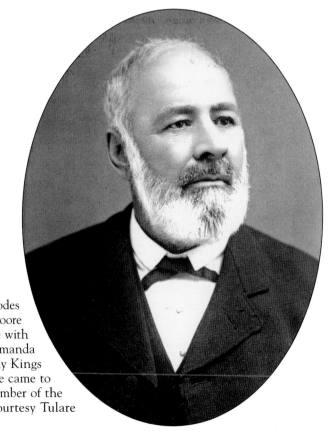

Kings County pioneer Daniel Rhodes settled just east of present-day Lemoore in 1857, bringing a herd of cattle with him from Gilroy. He married Amanda Esrey, a member of another early Kings County pioneer family. Before he came to Kings County, Rhodes was a member of the Donner Party rescue party. (Courtesy Tulare County Library.)

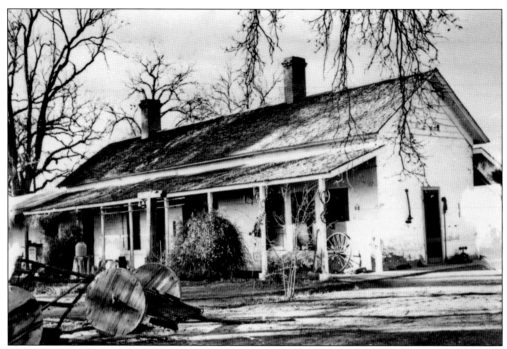

Daniel Rhodes built this adobe ranch house, which still stands today and is marked by California Historical Marker No. 206. His wife's brothers, Jonathan and Justin Esrey, came to King County at the same time and built their own adobe home just a short distance away from the Rhodes adobe. Unlike the Rhodes adobe, the Esrey home remained standing only into the 1920s. Related photographs are on pages 34 and 35 of Images of America: *Hanford*. (Courtesy King County Museum.)

Another early pioneer Kings County family was the Brooks family. Georgia Brooks (left) and her sister Mary are seen in this formal portrait probably taken prior to their coming to Kings County in 1857. Georgia Brooks was a schoolteacher in Lemoore for about 20 years and never married. She donated a number of family photographs, including this one, to the Kings County Museum. (Courtesy Kings County Museum.)

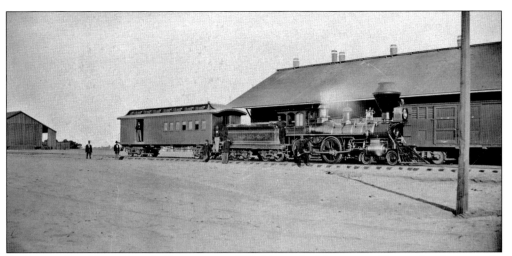

Dr. Lovern Lee Moore founded Lemoore in 1873. He applied for a post office under the name La Tache, but postal officials rejected that name in favor of a name they created from the doctor's middle and last names, and Lemoore was born. Four years later, the Southern Pacific Railroad built the rail line just north of the village. The first passenger train to enter Lemoore on that rail line is shown here. It signaled that Lemoore was connected to the rest of the world. (Courtesy Kings County Museum.)

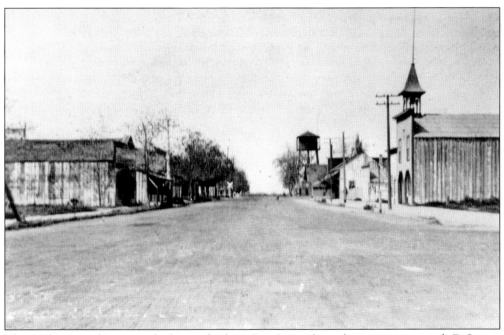

This early view of Lemoore looks north along Fox Street from the intersection with D Street. To the right can be seen the distinctive bell tower of the Lemoore Firehouse. Further down on the same side of the street is the water tower, located just north of the railroad tracks. An early railroad crossing sign can just barely be seen to the left of center. The firehouse was demolished in 1924. (Courtesy King County Museum.)

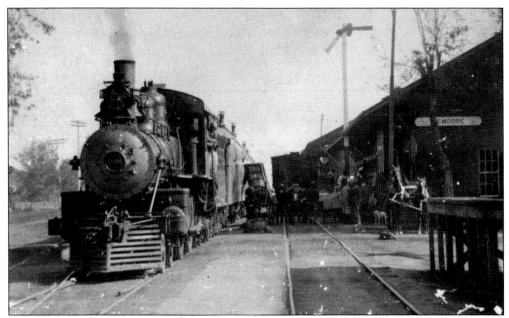

The Southern Pacific station was on the north side of E Street at the intersection of Heinlen. Today the location is part of a proposed downtown modernization project called the Lemoore Youth Plaza. The railroad was north of Lemoore, but like other towns across the county, it gravitated toward the railroad. The early town was south of Bush Street, across Lemoore Avenue from the current high school. The city center moved northward three blocks to fill the gap between Bush and E Streets. (Courtesy Kings County Museum.)

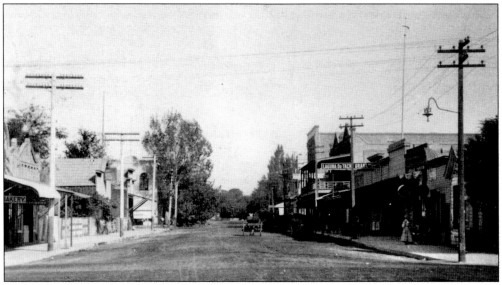

This undated view of D Street looking west is from around the beginning of the 20th century. Electric street lighting has been laid in and electricity and phones run to businesses, but cars have yet to make their appearance. A sign for a Laguna de Tache land sales office is on the right side of the street. Next to it are a bicycle shop, a store selling ice, and Mooney's Hardware. On the opposite side of the street are a bakery, a print shop, a livery stable, and a general merchandise store. (Courtesy Kings County Museum.)

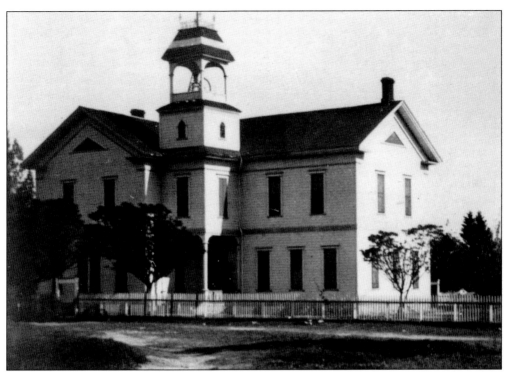

Lemoore Grammar School was founded around 1873 to accommodate students from the old Lake School and from as far away as the declining town of Kingston. The building pictured here was built in 1911 on the corner of Bush and Follet Streets, across Lemoore Avenue from the current high school. It was abandoned and sold in 1937. (Courtesy Kings County Library.)

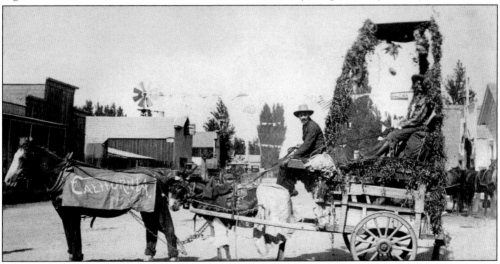

Hanford photographer H. C. Tandy took this picture at approximately the same location as seen at the bottom of page 28. The float is ready to take part in the annual Fourth of July parade. The buildings in the left background give some clue as to the date, as most of the structures on the left side of the street burned down during the September 10, 1889, fire that destroyed much of the town. The rebuilt brick buildings can be seen on the left-hand side of the photograph on page 28. (Photograph donated by A. Howell, courtesy Kings County Museum.)

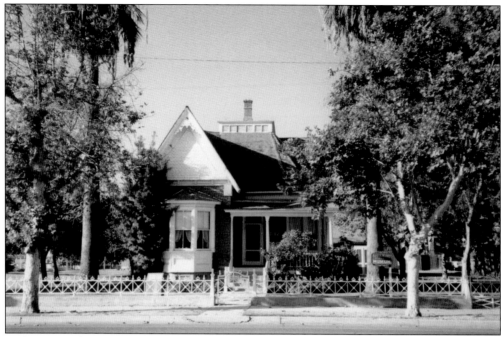

Built in 1893, the Sarah A. Mooney Museum building was the home of Aaron and Sarah Mooney. Aaron Mooney owned a hardware store on D Street and served as the town undertaker. The house was donated to the city and serves as a museum today. It is located at 542 West D Street. (Courtesy Kings County Museum.)

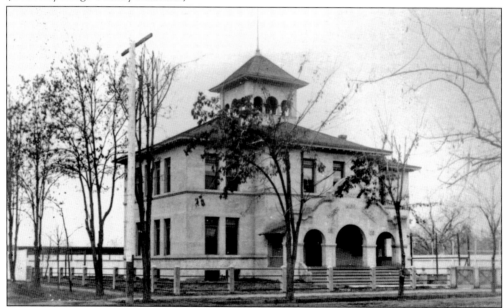

Lemoore High School was established in 1900 with 35 students meeting in Heinlen Hall. Increasing enrollment led to the construction of this building in 1903. Located on the block on the northwest corner of Fox and B Streets, now the location of the city offices, this building served as the high school until 1924, when the existing high school was opened. (Courtesy Kings County Museum.)

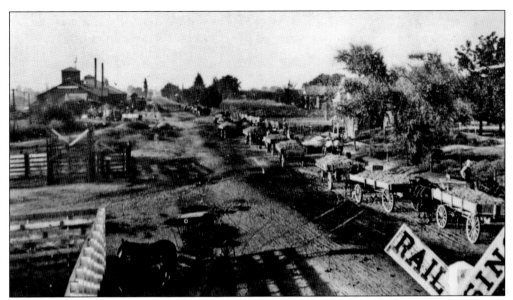

Lemoore/Eighteenth Avenue is seen looking north from the railroad tracks during the first decade of the 20th century. Development is just beginning, consisting of stock corrals and the Italian Swiss Colony Winery (the large building in the left background), constructed in 1902. Wagons loaded with grapes are lined up waiting to unload at the winery. About the time this photograph was taken, the winery produced over half a million gallons per year. (Courtesy Kings Count Museum.)

The Lemoore Fire Company posed for this 1909 photograph. It was organized in 1890 and was the forerunner of the city fire department. Members of the company shown here are fire captain Nelson, Charles Barrett, Dr. Lovelace, Mace Allen, Will Holser, Frank Blakely, Tom Esrey, Fernando Michel, Jim McKenna, Lovelace Barrett (sitting in the center, son of Charles Barrett), Mack Lovelace (a founding member), Sandy McGlashan, Clarence Cather, Al Brownstone, Louis Goodman, George Randall, Frank Vail, Zenith Cather, and Ernest Abrams. (Courtesy Kings County Museum.)

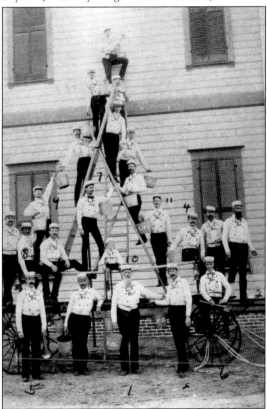

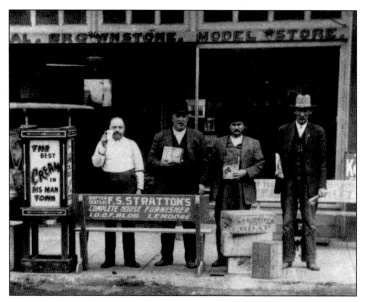

Al Brownstone's store is pictured some time after 1904—the date is indicated by the advertisement on the back of the bench for the IOOF building, which was not built until 1904. Brownstone was a member of the Lemoore Fire Company and active in civic affairs. The S. F. Stratton named on the bench advertisement is not the same Stratton for whom Stratford was named. (Courtesy Kings County Museum.)

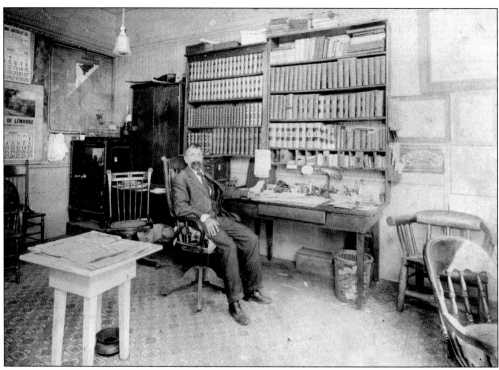

Ed Erlanger is shown in his law office in Lemoore prior to 1900. Erlanger was an attorney and justice of the peace and a very early resident of the area that became Kings County. He resided in Kingston in his younger days, working in the general store there. He was present in the store when Tiburcio Vasquez robbed the town (see chapter three in Images of America: *Hanford*). After Kingston died, Erlanger moved to Lemoore, where he raised world-class horses. (Courtesy Kings County Library.)

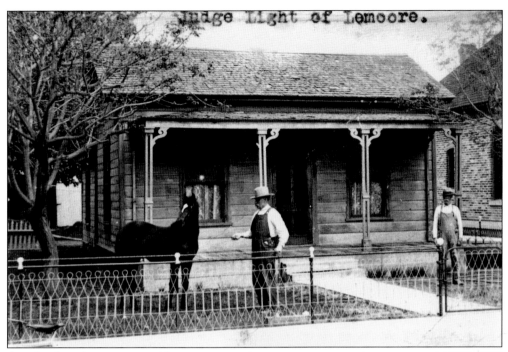

Another longtime county resident was Judge Henry J. Light, who served as justice of the peace for the west side and ranched in Sunflower Valley. He retired to this home in Lemoore. (Courtesy Kings County Museum.)

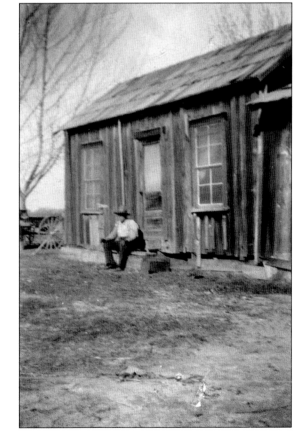

Fagundas Lopes was an old-time vaquero who lived in this cabin south of Lemoore. He came to Lemoore as a young man but was retired when this photograph was taken. Like Judge Light, he was a tie to the earliest days of Kings County history. (Courtesy Kings County Museum.)

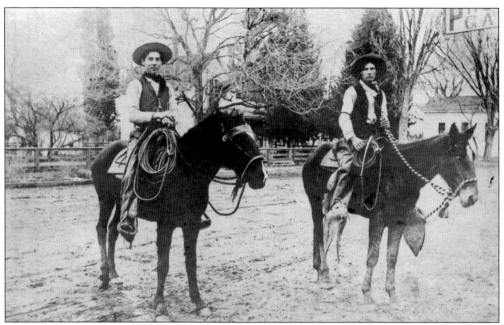

On the back of this interesting period photograph are written the words: "Two real cowboys of the Lemoore District." Sadly the writer neglected to record their names or any additional information. Particularly interesting is the side-by-side comparison of two differing cowboy rigs. Both riders employ the traditional *jáquima* bridle, commonly known as a hackamore today. (Courtesy Kings County Museum.)

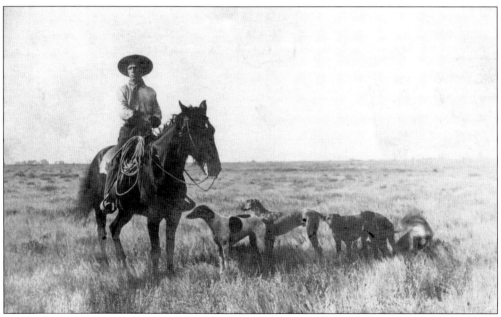

Unlike the two vaqueros at the top of this page, Lee Chrissaner uses a bridle and bit. Dogs were used with both cattle and sheep, but shepherds rarely used horses or lariats to herd sheep. This photograph was taken near Lemoore, but no date is provided. (Courtesy Kings County Museum.)

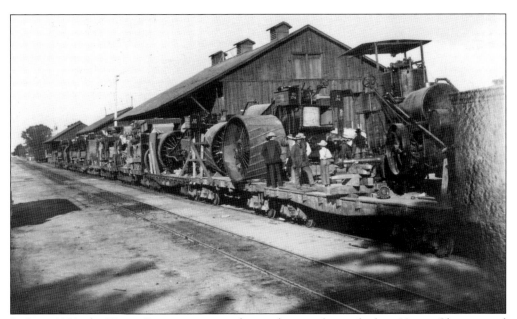

In June 1901, the Kings County countryside was forever changed when Hiram Clawson and Frank Blakeley arrived in Lemoore with five disassembled steam-driven tractors on flatcars. The parts were unloaded and the tractors assembled next to the tracks. Once assembled, they were driven south to Stratford and put to work. Some years later, Blakeley accepted a contract with a development company in Corcoran to plow an incredible (for the time) 2,000 acres of land. (Courtesy Kings County Museum, from a photograph provided by Evelyn Vaughn.)

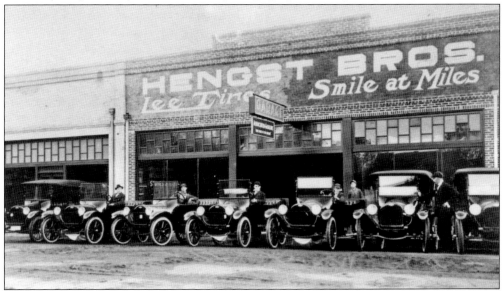

The age of mechanization had arrived, and horse-powered farming would rapidly come to an end. Vaqueros would still have a place in cattle ranching, but as cars proliferated, blacksmiths and livery stable owners began to shift their businesses from servicing horses to cars. Bill and George Hengst of Lemoore did all they could to speed up the process by proudly displaying these shiny new 1913 model Chevrolets for sale at $750 outside their garage. (Courtesy Kings County Museum, from a photograph provided by William Hengst.)

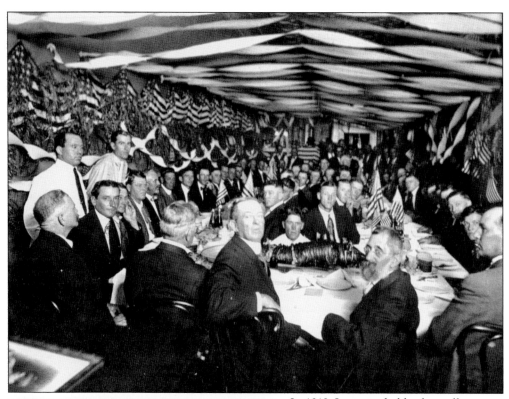

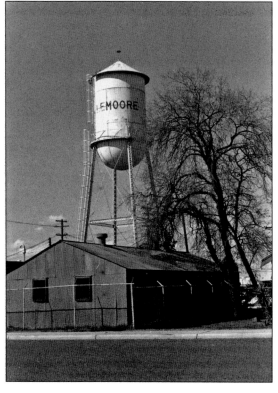

In 1918, Lemoore held a farewell banquet for the first group of local boys to head off for war with the American Expeditionary Forces. Among those honoring the new soldiers were Joe Biddle (left center, turned to face the camera), Ed Erlanger (to the right of Biddle, wearing a beard), and Ed Sellers. (Courtesy Kings County Museum.)

A landmark for many years, the Lemoore Water Tower was demolished in 1991. The removal divided the city, and feelings can still run hot whenever the subject is mentioned. (Courtesy Kings County Library.)

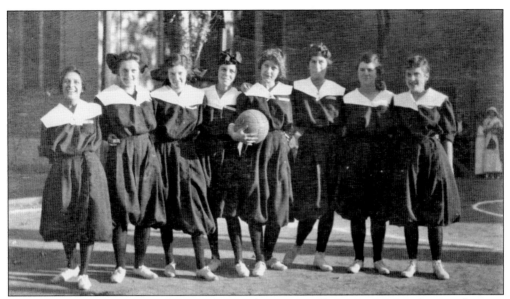

Lemoore High School has a deep tradition of sports excellence starting early in its history. According to information on the back of this photograph, these girls were California state champions, probably in 1922. (Courtesy Kings County Museum.)

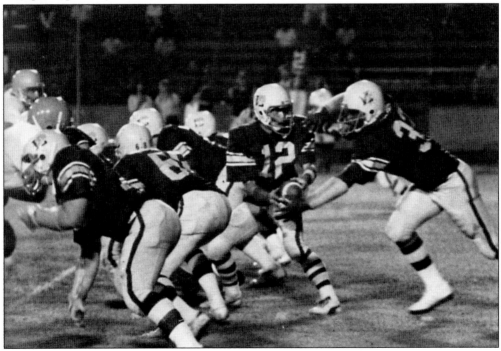

In a more modern era, this 1980 photograph from the Lemoore High School yearbook shows current Lemoore High athletic director and former Tigers football coach Thom Sembritski (12) handing off to Otis Tolbert (33). The Tigers were undefeated West Yosemite League champions that year. Tolbert was the team captain. He went on to join the U.S. Navy and was killed on 9/11 in the attack on the Pentagon. He is member of the Lemoore High Athletic Hall of Fame. (Courtesy Lemoore High School.)

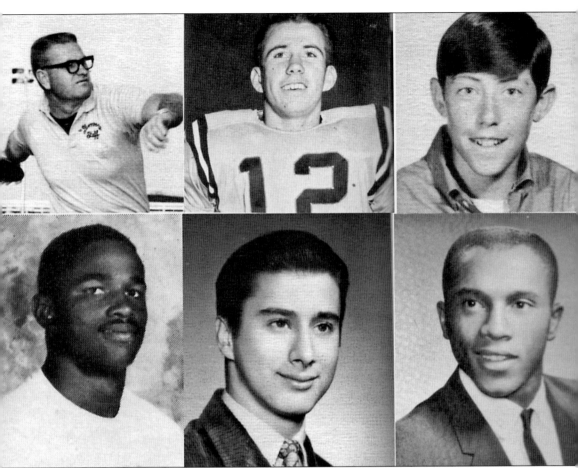

Among the many outstanding individuals who have gone on to success in the world outside Lemoore, some stand out more than others. Taken from the pages of the Lemoore High School yearbook are Doug Fraley, Fresno State and Olympic track coach and member of the Pole Vaulting Hall of Fame (top, left); Dale Messer, College All-American and NFL player (top, middle); Michael Baker, NASA astronaut (top, right); Lorenzo Neal, NFL All-Pro running back (bottom, left); Steve Perry, lead singer for the legendary rock group Journey (middle, left); and Tommie Smith, the 1968 Olympic 200-meter champion and civil rights icon, whose black-fisted protest on the Olympic medal stand electrified the world and is one of the most memorable moments of the 1960s (bottom, right). (Courtesy Lemoore High School.)

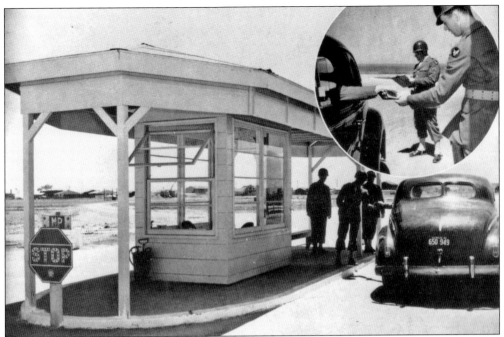

During World War II, the U.S. Army Air Forces established a flight school just west of Lemoore, across Highway 198 from present-day Naval Air Station (NAS) Lemoore. The front gate of that base is pictured in 1943. Among those stationed at Lemoore during the war were Roberto Casino, brother of movie star Rita Hayworth, and Robert Lee Scott, author of the classic wartime book *God is My Co-pilot*. (Courtesy Kings County Library.)

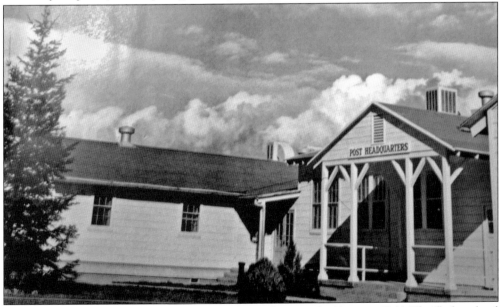

The headquarters of Lemoore Army Air Field was photographed here in 1944. The flight school typically graduated five classes a year, designated by year and a letter of the alphabet corresponding to each of the five graduating classes. This photograph was from the 44-E yearbook, designating the fifth graduating class of 1944. (Author's collection.)

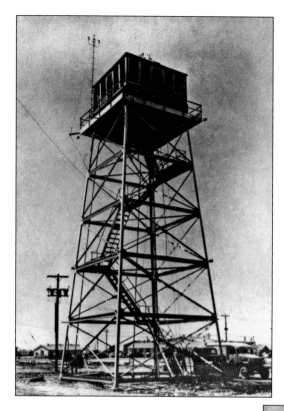

The base flight tower was photographed here in 1943 and oversaw all takeoffs and landings at the field. An ominous reminder that flying is dangerous—even within the confines of a training base—lies in the presence of an ambulance at the base of the tower. The flight risks not withstanding, at least some of the students earned the approbation "San Joaquin Valley Beaufighters" for their expertise in seeking out and engaging in armed combat with local members of the opposite sex. (Courtesy Kings County Library.)

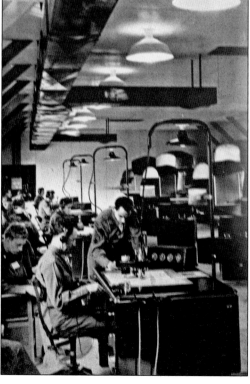

At part of their ground-school training, pilots flew in a simulator. Known as the LINK trainer, it was monitored and controlled from the room pictured here. It is more than coincidence that just a few hundred yards away and nearly 40 years later, the Hughes Aircraft Company developed and installed the most sophisticated aerial combat trainer the world has ever known at NAS Lemoore. (Author's collection.)

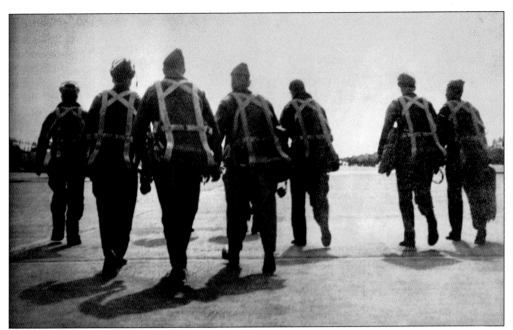

Pilots cross the tarmac landing strip to their planes to begin another long training day. It was a scene repeated thousands of times around the world during World War II—most of the time, it was the last walk for at least one of the pilots. (Author's collection.)

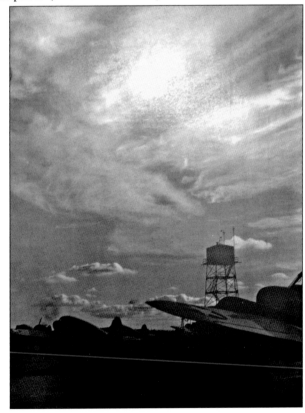

Titled "Passing Light," this striking photograph graced the cover of the class 44-E yearbook. The planes silhouetted against the evening sky are Cessna AT-17 Bobcats used as multiengine (bomber) trainers for the advanced flight-training course. (Author's collection.)

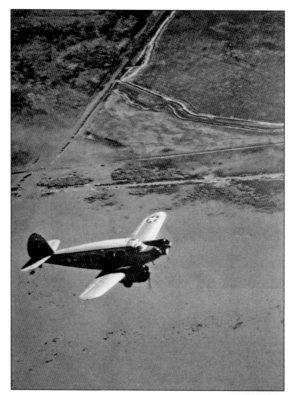

This AT-17 was photographed on a training mission over Tulare Lake in 1944. The lake was nearly full the entire war. The navy even established a seaplane base on the lakeshore that led to one navy Beaufighter, Ned Gentilini, becoming a permanent POW—"prisoner of wedlock." He married Stratford daughter Alice Irigary, and the two operated Irigary's Basque Restaurant in that town until 1979. (Author's collection.)

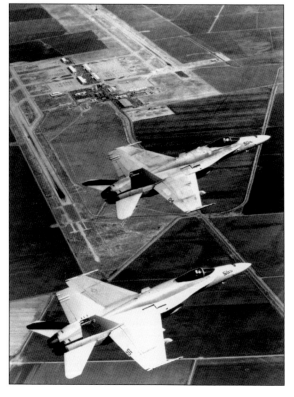

Nearly 50 years later, two FA-18 strike fighters fly the same skies. Below them can be seen Reeves Field, the name given to the airfield at NAS Lemoore. It was originally the name of the airfield on Terminal Island near Los Angeles, but when that facility was decommissioned, the name was transferred to Lemoore. Named in honor of Rear Adm. Joseph Mason Reeves, an early naval aviation observer and a pioneer in the tactical deployment of aircraft carriers, it was dedicated November 20, 1961. (U.S. Navy photograph, courtesy Kings County Library.)

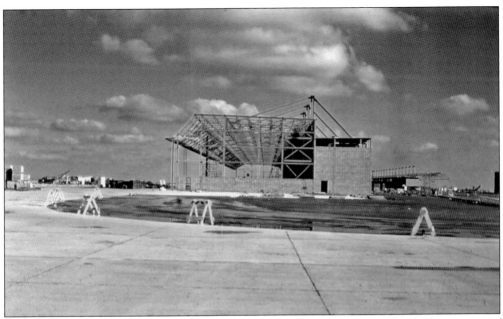

NAS Lemoore (established in 1961, elevation at 225 feet) began in 1954 with U.S. Department of Navy surveys of the old army airfield as a possible location for a new air base for the 12th Naval District. Negotiations were held in secret, and on August 11, 1955, the *Lemoore Advance* announced the navy's intentions to build a station in the area. In 1956, President Eisenhower signed the bill appropriating funds for the base—initially $81 million. (Courtesy Kings County Library.)

Land acquisition for the base began in early 1957, starting with the purchase of the old Lemoore Army Air Base property from the City of Lemoore, to whom it had reverted after the war. Ground-breaking was held on June 29, 1958, and by May 1, 1960, the first eight families moved into base housing. Two parallel runways, 13,502 feet long, were laid out 4,600 feet apart, with aircraft parking and maintenance hangars located between. On May 4, the first jets—three A-4 Skyhawks from VA-125 based at Moffett Air Field— landed on the new runway. Capt. Howard M. Avery was named commanding officer of the station in May 1961 and the base was commissioned on July 8, 1961. It remains the newest air station in the navy to this day and cost more than $154 million to build. (Courtesy Kings County Library.)

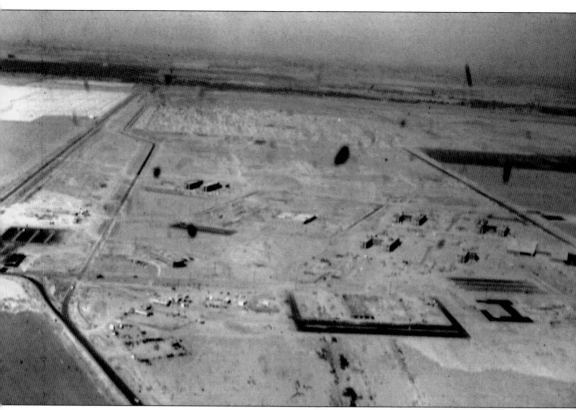

In February 1981, the first F/A-18 Hornet arrived at Lemoore. Pilots from NAS Lemoore flying Hornets participated in various actions around the world, including Operation Desert Storm in 1990 and 1991. Upon the transfer of NAS Miramar to the U.S. Marine Corps in 1993, NAS Lemoore became the sole base for U.S. Navy fighter/attack jets on the West Coast. In July 1998, NAS Lemoore was chosen as the West Coast base for the F/A-18E/F Super Hornet, the navy's newest strike fighter; the first Super Hornets landed in Lemoore in November of that year. Four new fleet squadrons were added to the Lemoore complement from 2001 to 2004. (Courtesy Kings County Library.)

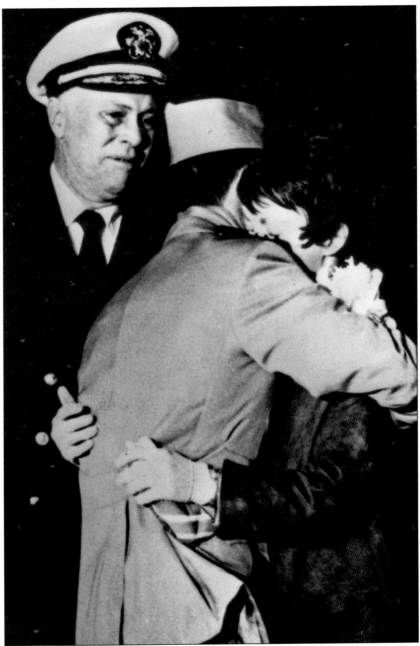

During the Vietnam conflict, NAS Lemoore played a major role, deploying as many as 12 squadrons to Southeast Asia. Almost 130 Lemoore-based pilots were shot down over the course of the war, and 87 became POWs or MIAs—more than any other single military establishment. Forty-three of the POWs released at the end of the war were from Lemoore. Lt. (jg) Everett Alvarez Jr., flying with VA-144 from Lemoore, was the first American pilot shot down by North Vietnamese forces during the war. He was taken as a POW and later released. The family housing unit at NAS Lemoore was named in his honor. In this photograph, Comdr. Brian Woods is greeted by his wife after years as a Vietnamese POW. Rear Adm. Joseph W. Williams, commandant of the 11th Naval District, looks on. (U.S. Navy photograph, courtesy Kings County Library.)

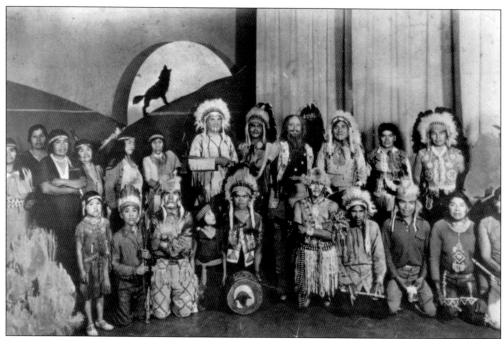

Just south of Lemoore, the Santa Rosa Rancheria is home to over 200 members of the Tachi Yokuts tribe. Established in 1934, the reservation is located on 40 acres of land at the site of an ancient Tachi village though which the Mussel Slough runs. In this undated photograph, probably taken in the mid-1980s, members of the San Rosa reservation join with non-tribal members to celebrate Tachi culture. In the background is the Santa Rosa Tachi logo, a howling coyote silhouetted against the sun—a clear reference to the ancient Yokuts myth "How Coyote Stole the Sun." (Courtesy Kings County Library.)

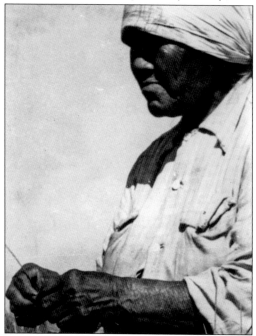

Yoi-mut (Josie Alonzo) was the last member of the Chunut tribe, which lived on the northeast shore of Tulare Lake. She married a Tachi, was descended from the Wowol tribe of Atwells Island where the town of Alpaugh is today, and was a member of all three Tulare Lake tribes. She spoke six Yokuts dialects, read and wrote English and Spanish, and was a major source of Yokuts history and culture. She died in Hanford on February 3, 1937. (Courtesy Hanford Carnegie Museum.)

Anthropologist John Peabody Harrington, shown in this undated photograph, documented much Yokuts history for the Smithsonian Institution. He interviewed many Tachi individuals between 1914 and 1920 and was responsible for preserving much Tachi history and culture that would otherwise have been lost. (Smithsonian Institution photograph, courtesy Kings County Museum.)

Josie Atwell, mother of current tribal chairman Clarence Atwell, and Leon Manual demonstrate how to build a traditional Yokut reed boat or *ah-ya*. According to Frank Latta, who like Harrington studied the culture of the Tachi Yokuts, the Yokuts called Tulare Lake *Pah-áh-su*. For more information on the Yokuts, see chapter one in Images of America: *Hanford*. (Courtesy Kings County Museum.)

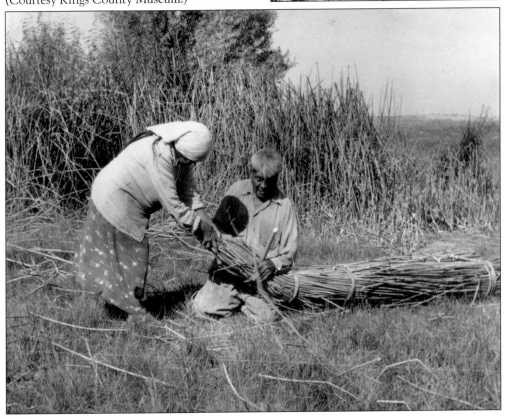

Kings County Office of Education Music consultant Marjorie Whited (later Cummings) took an interest in the music, songs, and oral tradition of the Tachis and preserved many of their songs and culture. She is pictured here during the 1938–1939 school year at one of the county schools. She recorded many of the songs using Tachi singers; the recordings are being digitized by the author of this book to make them more accessible to the general public. (Courtesy Hanford Carnegie Museum.)

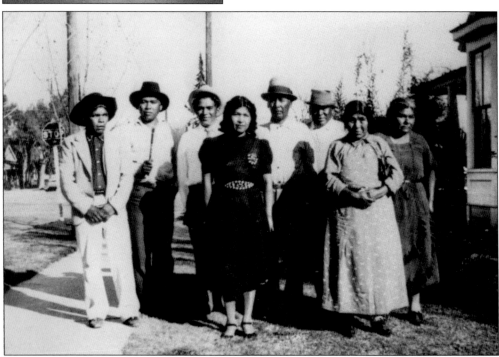

In February 1940, Marjorie Whited recorded numerous traditional Tachi songs performed by this group of Tachi singers, who were taught the songs by Clarence Atwell Sr. From left to right the singers are Thomas P. Thomas, John Brunell, Clarence Atwell Sr., Bessie Brunell, Jim Brunell, Nick Sisco, Josie Atwell, and Belle Mendoza. (Photograph by Marjorie Whithed, courtesy Hanford Carnegie Museum.)

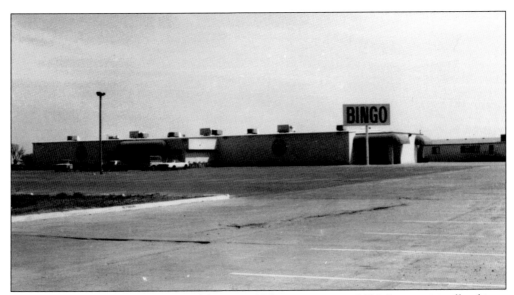

The Tachi Palace, opened in 1983, celebrates its 25th anniversary in 2008. It was originally a bingo parlor, as shown in this 1991–1992 photograph. Two years after this photograph was taken, the palace was converted to a casino under the Indian Gaming Regulatory Act of 1988. Today the Tachi Palace Hotel and Casino employs over 400 people and has been the mechanism by which the Tachi people have prospered. (Photograph by Steve Emanuels, courtesy Kings County Library.)

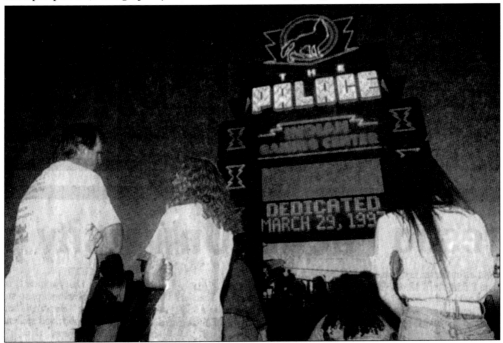

On March 29, 1997, the Tachi tribe dedicated a new sign for the Palace Indian Gaming Casino. The sign is eight stories tall and uses over 4,000 lightbulbs and 2 miles of neon tubing to advertise the casino. In more recent years, the tribe has expanded its operations beyond the boundaries of the reservation itself, including a hotel in Hanford and numerous business and cultural projects in nearby Lemoore. (*Hanford Sentinel* photograph by Gary Feinstein.)

Arches welcome visitors to the unincorporated community of Stratford. The Empire Investment Company bought the 15,000-acre Empire Ranch from the Bates, Davis, and Miller Company in 1906 and subdivided the ranch into farming acreages. The next year, the Southern Pacific Railroad laid a spur line through the area and built a depot. In 1908, the railroad platted a town. An application for a post office named Stratton after Empire Ranch foreman Bill Stratton was submitted in 1909, but a post office by that name already existed, and the second choice, Stratford, became the town's official name in 1910. (Photograph donated by Jack Stone, courtesy Kings County Library.)

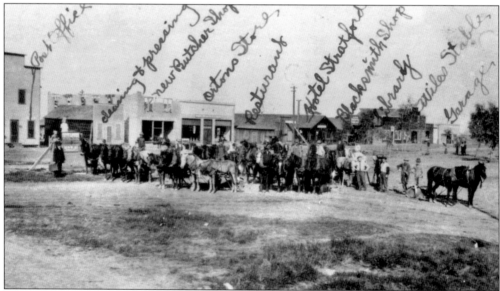

Early Stratford businesses on the north side of Main Street are identified on this photograph. From left to right are the post office, a cleaning and pressing service, a new butcher shop, Orton's Store, a restaurant, the Hotel Stratford, Ed Strain's blacksmith shop, the county branch library, Wiles' Stables, and a garage. (Photograph donated by Maxine Wade, courtesy Kings County Library.)

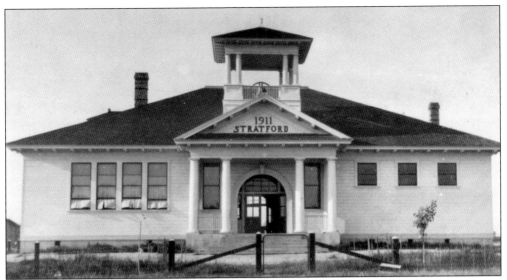

Stratford School was formed on October 11, 1907, as Stratton School but later changed to conform to the official town name. This four-room schoolhouse was completed in 1911 and was photographed the next year. It stood, as have all Stratford school buildings since, on the site of the current Stratford School. (Courtesy Kings County Museum.)

On May 5, 1923, a bond issue for $50,000 was passed, and construction on a new brick building shortly commenced. This transitional photograph was taken while the new structure was being built; that construction can be seen on the right side of the photograph. The older building was torn down when the new building was complete. (Courtesy Kings County Museum.)

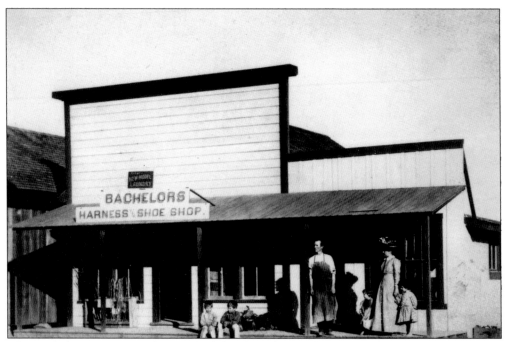

The Bachelors were an early Stratford family and ran a harness and shoe store as a family enterprise. The entire family was photographed one day on the porch of the shop. Pictured from left to right are Stanley, Harvey, Judson, Evelyn, Rose, and Florence. The family also operated a laundry from the same location—no wonder everyone in the family had to be involved! (Jack Stone photograph, courtesy Kings County Library.)

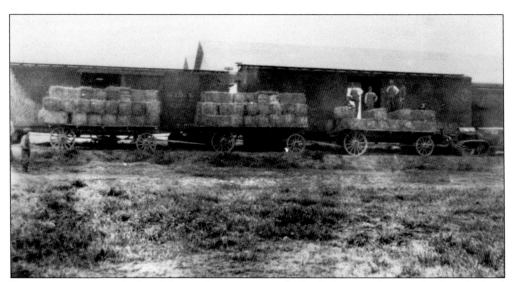

These wagons are stacked with hay and are waiting to be loaded onto railcars at the Stratford rail station. The landmark Southern Pacific depot at Stratford was demolished in 1969. (Jack Stone photograph, courtesy Kings County Library.)

In 1936, Stan Badrabor delivered groceries via automobile, still a recent phenomenon in Stratford at that time. (Courtesy Kings County Museum.)

Stratford even had a Shell service station with a full-service crew. The pumps used the older glass bowl system, wherein gasoline was pumped into the bowl on the top and then gravity-fed from the bowl into the car. The amount of gas was calculated using marks on the bowl. (Courtesy Kings County Museum.)

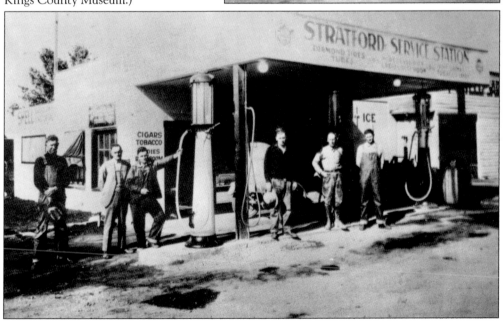

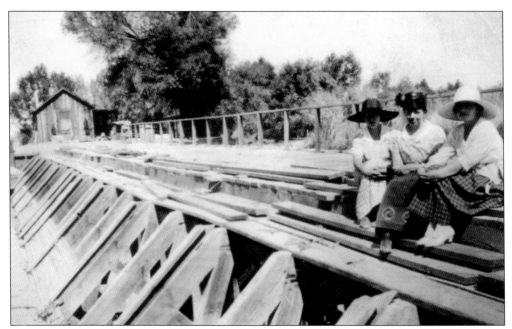

The first telephone in Stratford was installed in the home of the Stratford weir tender, seen at the far end of the weir in this photograph. Enjoying the Stratford sun are Marie Winship, Elaine Stone, and an unidentified friend. (Jack Stone photograph, courtesy Kings County Library.)

Stratford developed into a bustling town, as this c. 1930 photograph shows. The view is looking west down the main street of town, showing the same buildings seen in the bottom photograph on page 50. Starting on the right, closest to the camera, are the Hotel Stratford, Lees Restaurant, Orton's Store, the butcher shop, and beyond it, the building containing the Stratford branch of the county library. (Courtesy Kings County Museum.)

The Stratford branch of the Kings County Library was photographed here around 1930. The rather dilapidated building shown was replaced by a new plaster-and-lathe building in 1938. That newer branch served until it was replaced in 1990, when the author served on the county library board. The patrons in front are not identified. (Courtesy Kings County Museum.)

A new brick building replaced the old wooden Hotel Stratford and restaurant. Dinners cost 50¢. (Courtesy Kings County Museum.)

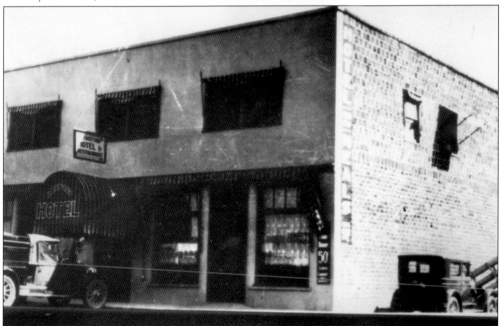

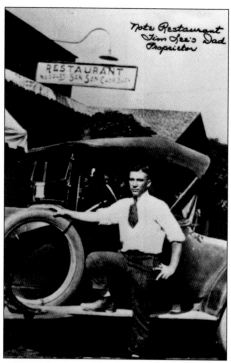

Harvey Bachelor stands in front of Sook Lee's Chinese Restaurant. Harvey was pictured as a young child with his family in the photograph on the top of page 52. Sook Lee's son Tim later moved to Lemoore and went into business in that city. (Courtesy Kings County Museum.)

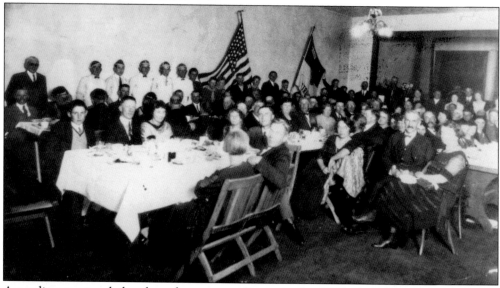

Attending a catered chamber of commerce dinner in the 1920s are, among others, county supervisor Mark Carter, Ambrose Blakeley, Stan Bachelor, Claude Wolfe, Earl Mathews, "Speed" Prince, Glenn Tuzzi, scoutmaster Elmer Downing, Mr. and Mrs. William Smith, Cecil Fowler, Buck Kolbenstetter, Mr. and Mrs. Charlie Snowden, Mr. and Mrs. D. C. Jones, Mr. and Mrs. J. M. Case, Mr. and Mrs. Carl Danielson, Mr. and Mrs. Jack Darrell, Mr. and Mrs. Edman, the Reverend and Mrs. Bradley, Mr. and Mrs. J. A. Kloniger, Alma Bachelor, Vera Belknap, Mr. and Mrs. George Skaggs, Mr. and Mrs. Charlie Meters, Mr. and Mrs. Roy Powell, Mr. and Mrs. Roy Newton, Ruth Orton, Clarence G. Train and Birdie, Jim Skaggs, G. B. Chinn, and Fred Newton. (Jack Stone photograph, courtesy Kings County Library.)

Three

CORCORAN, LAKESIDE-GUERNSEY, AND TULARE LAKE

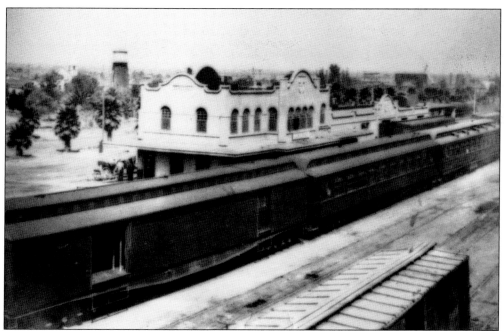

The city of Corcoran was originally just a railroad junction for the San Francisco and San Joaquin Valley Railroad. Some accounts claim that the town was named after the junction, which was named for Thomas Corcoran, a railroad superintendent. Other accounts claim the town was named after Gen. Michael Corcoran, an early pioneer who ran a steamboat between Stockton and Tulare Lake. The Atchison, Topeka, and Santa Fe railroad depot in Corcoran was built in 1907 at a cost of about $20,000. The photograph here was taken about 1915. The depot was renovated in 1999 and now serves as both a community showplace and an Amtrak station. (Courtesy Hanford Carnegie Museum.)

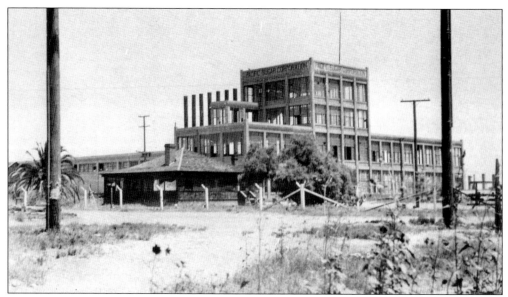

In 1908, the Pacific Sugar Company built a sugar beet processing plant in Corcoran and tried to create a local sugar industry, but the owners ended up in prison over what turned out to be a big boondoggle. The expensive structure sat vacant until World War I, when the government leased it as a military supply depot. (Photograph donated by Bob Marcellous, courtesy Kings County Library.)

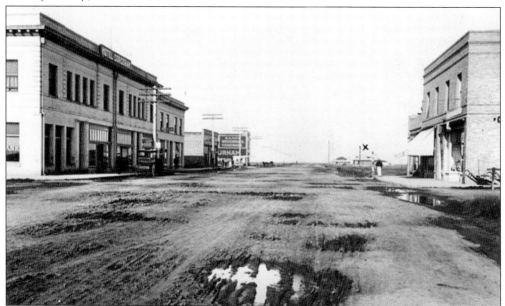

This view of Whitley Avenue looking west clearly shows the Hotel Corcoran on the left, built in 1910. The building to the right housed the Corcoran department store, predecessor of the Corcoran Mercantile Company. The avenue is named after Hobart J. Whitley, the individual given the most credit for developing the town. In 1905, he bought 32,000 acres of land and laid out the city on a portion of it. The exceptional productivity of the Tulare Lake bottom encouraged farmers and budding entrepreneurs to give the new town a try. Whitley was also the founder of Hollywood. (Courtesy of Kings County Museum.)

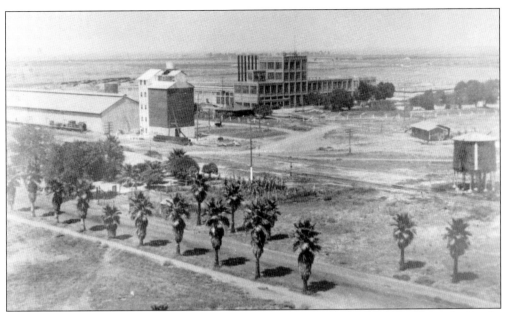

This early view of Corcoran features palm-lined Otis Avenue in the foreground and the Pacific Sugar Beet plant and von Glahn grain storage facilities in the background. Otis Avenue was named for Harrison Gray Otis, publisher of the *Los Angeles Times* and a close friend of Whitley. Whitley tried to change the town name to Otis, but no one went for the idea. The palms along the avenue were planted in 1905 and many still line the street to this day. (Courtesy Kings County Museum.)

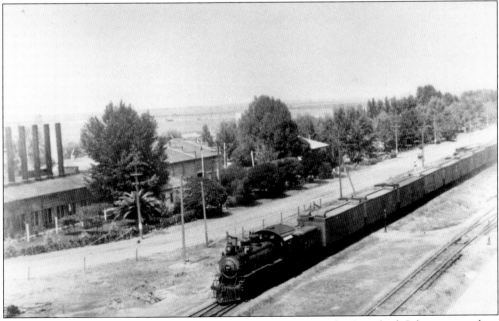

An engine of the Santa Fe Railroad pulls a string of cars past the Standard Oil pumping plant in Corcoran. The pumping plant and a small Santa Fe depot were the only buildings standing when Whitley bought the land that became the city of Corcoran. The pumping plant was razed in the early 1930s. (Courtesy Kings County Museum.)

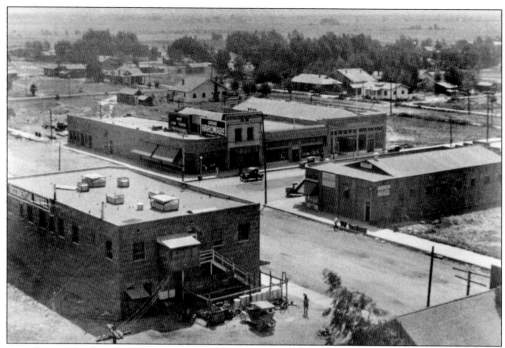

Another early Corcoran business was the Occidental Hotel, on the corner of Whitley and Chittenden Avenues. It is pictured here in 1915. Across Whitley is the Nees building, which housed a drugstore, and across Chittenden from the Nees building is Cross Hardware. A county branch library was located in the Nees building at one time (Courtesy Kings County Museum.)

The Corcoran Garage dominates the scenery in this 1915 photograph. It was located on Chittenden Avenue. (Courtesy Kings County Museum.)

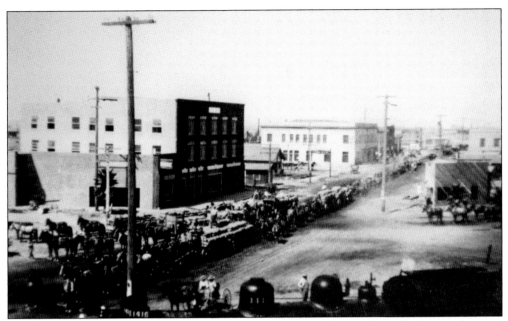

Wagons line up along Whitley Avenue waiting to load local Tulare Lake products onto the train that can just be seen in the foreground. Tulare Lake agricultural products find their way around the world from this depot. The photograph is undated. (Courtesy Jay Clark.)

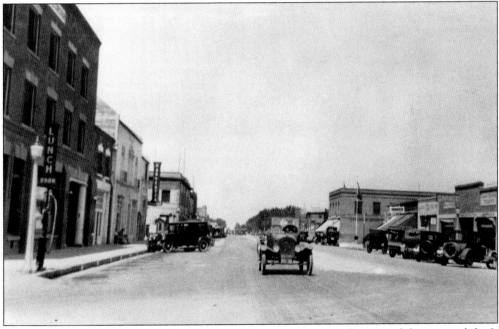

Downtown Corcoran is pictured in the late 1920s after the introduction of the automobile. It was about this time that Kate Boswell arrived in Corcoran to join her husband, Bill, who had come from their native Georgia to help his brother J. G. farm cotton. (Photograph donated by Bob Marcellus, courtesy Kings County Library.)

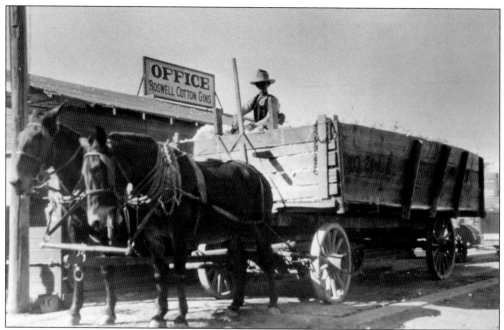

A worker delivers cotton to the J. G. Boswell Company cotton gin. The J. G. Boswell Company is the biggest farm in the world, currently run by J. G.'s son Jim (J. G. II). The elder Boswell came to Corcoran in 1923 and immediately saw its promise as a cotton-producing center. The "King of California" is also the king of cotton. J. G. married Ruth Chandler, the granddaughter of *Los Angeles Times* publisher Harrison Otis, after whom Otis Avenue in Corcoran is named. (Photograph donated by Bob Marcellus, courtesy Kings County Library.)

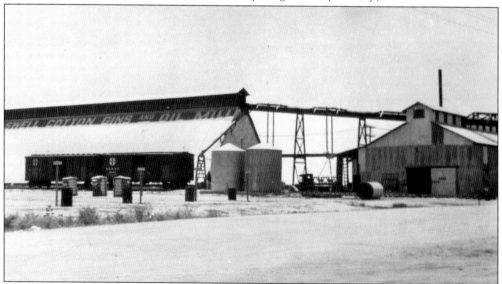

The Boswell Company also built this cottonseed oil mill near Corcoran. Along with his brother Bill, Col. J. G. Boswell began buying land to grow cotton and kept on buying whatever land became available, often for pennies on the dollar from fellow farmers who lost their battle with Tulare Lake. Boswell never gave up, never sold land he owned, and never saw a tract of land that he didn't want. (Photograph donated by Bob Marcellus, courtesy Kings County Library.)

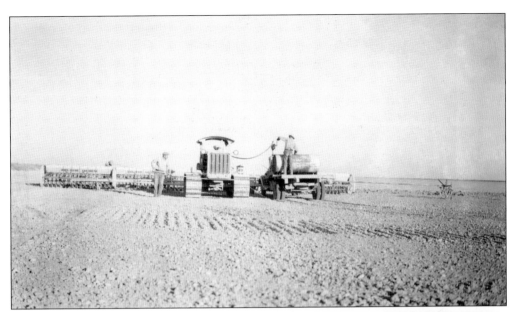

A tractor on the von Glahn ranch gets refilled in the field in this October 1937 photograph. At the time, Elmer von Glahn's ranch was well on its way to becoming the largest farm in the world and was bigger than Boswell and bigger than Salyer—at least for a time. (Courtesy Hanford Carnegie Museum.)

Elmer and Francis von Glahn are pictured about the time they came to Corcoran in 1915. In a town of characters, Elmer stood out. Everything he did was done large. When he opened his new office building, he threw a party for the entire town, hiring the biggest bands of the day and paying caterers to serve food and drink to everyone. Elmer made and lost three fortunes and worked for J. G. Boswell in between. He died penniless in 1972, having been duped into buying hundreds of thousands of acres of South American oil lands that turned out to be worthless. (Author's collection.)

Elmer von Glahn was the biggest single farmer in the world when this portrait was taken in the 1940s. He farmed over 55,000 acres, operated six different corporations, and spent money like it was Tulare Lake water. Both he and his wife were pilots, and they built the Corcoran Airport to fly to their widespread holdings. As a result, Elmer became known as the "flying farmer." He provided each of his foremen with Cadillacs that jokingly became known as "von Glahn pick-ups." (Author's collection.)

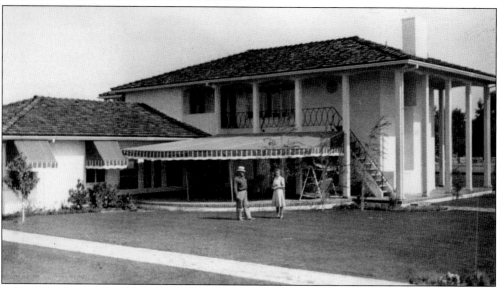

Still a Corcoran landmark, the von Glahn home on Whitley Avenue has eight bathrooms. During a down economic time, Francis helped make ends meet by operating a hairdressing business from the couple's then modest home. Elmer complained he could never find an empty bathroom and vowed to make sure it didn't happen again. Among the projects von Glahn was involved in was the construction of Highway 43 south from Corcoran to Allensworth, where it hooked up with a similar road-building venture from Wasco. In this photograph, Elmer and Francis stand on the lawn in front of their luxurious home. (Author's collection.)

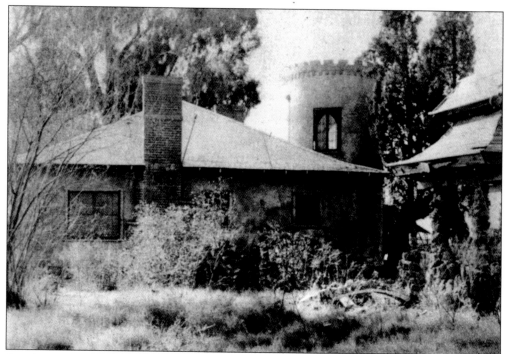

Another interesting Corcoran home was the Bliss Castle. Built in 1924 at 2224 South Dairy Avenue, the home of Guy and Rose Bliss featured leaded glass Gothic windows, twin turrets, and 14 rooms. The Blisses came to Corcoran in 1904, and Guy noticed very few water wells. He is reputed to have drilled more than 1,200 water and gas wells during his career. (Author's collection.)

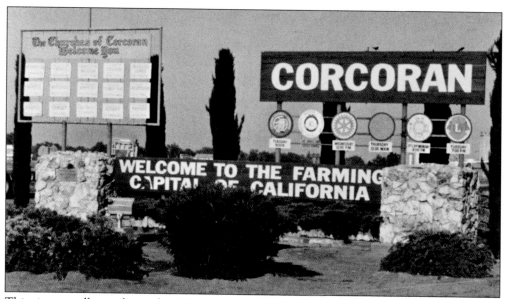

This sign proudly proclaims that Corcoran is the farming capital of California, which probably makes it the farming capital of the world. The world's biggest farms are located closest to Corcoran in the Tulare Lake basin. This photograph was taken in the 1980s, but the sign looks the same today. (Author's collection.)

Corcoran either has too much or too little water. This September 1959 photograph of a Tulare Lake basin levee road on the Salyer ranch illustrates that fact. A drainage ditch on the right carries excess water away from cultivated areas, while an irrigation ditch on the other side carries water to the crop. Clarence Sayler, founder of the Salyer farming enterprise, came to Corcoran in 1918. He once farmed as much as 88,000 acres—second only to J. G. Boswell. (Photograph by Carl H. Anderson, courtesy USDA Natural Resources Conservation Service.)

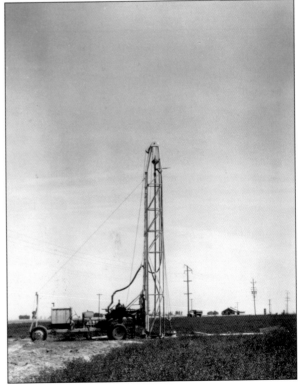

When the problem was too little water, well-drilling units like the one shown here on the Jake Verboon ranch were called upon to remedy the situation. Guy Bliss used small towed rigs like this one, in addition to larger units carried on trucks, to drill many of the 1,200-plus water and gas wells he sank over the course of his career. This photograph was taken on May 24, 1960, by D. Brooks. (Courtesy USDA Natural Resources Conservation Service.)

When the problem was too much water in the wrong place, pumps were called upon to remove it. This October 1964 photograph shows Keith Dampf inspecting the impellor of a large water removal pump used by Salyer Farms to drain flooded sections of reclaimed Tulare Lake farmland. Pumps like these—in conjunction with levees and drainage channels—allowed farmers to use land that was historically under water as part of Tulare Lake. (Courtesy USDA Natural Resources Conservation Service.)

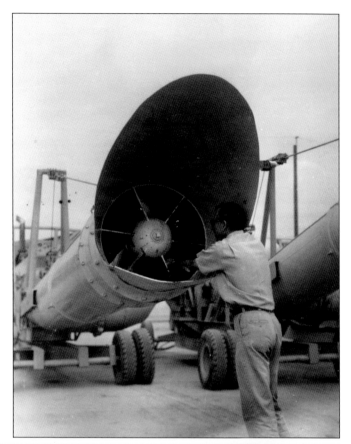

The successful large-scale farming of the Tulare Lake bed allowed locally owned farms to invest substantially in the Corcoran community. One such investment is the Kate H. Boswell Senior Center in Corcoran paid for by Boswell Farms in memory of Jim Boswell's wife, Kate Hall. Other investments in the town include the William Boswell Baseball Diamond, the community hospital, the YMCA, and an all-weather track at the high school. (Author's collection.)

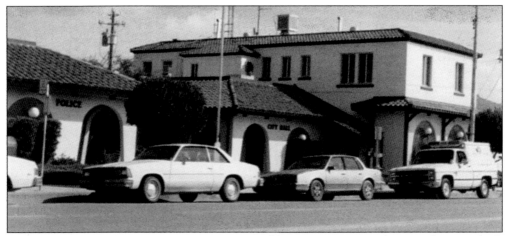

The Corcoran City Government Center is pictured here in a 1980s-era photograph. It was built as part of master plan to renovate the entire community. (Author's collection.)

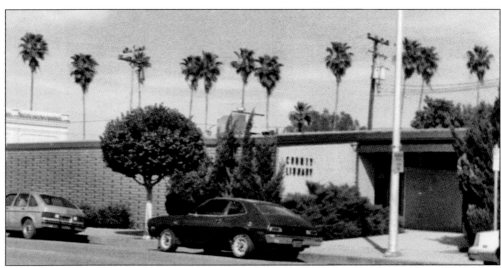

Kings County built a new sheriff's substation and library complex in 1959. The Corcoran branch originally opened in February 1913 and was located in the Storzbach building on Whitley Avenue. It was later moved to the old school building in the city park next to the Legion Hall (the Veteran's Building). After that building was condemned, the branch was moved back to Whitley Avenue and housed in the Neeb building until that structure was razed. (Author's collection.)

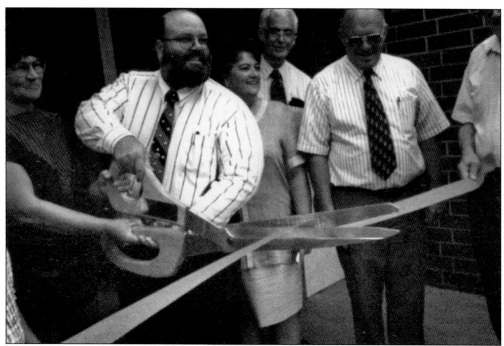

In 1997, the sheriff's substation was moved and the library expanded. Kings County supervisor Joe Neves is photographed cutting through the red tape at the rededication ceremony for the expanded library on July 22, 1997. To the left of Neves is the Corcoran branch librarian at the time, Joyce Craven, and to the right (from left to right) are supervisor Alene Taylor, county librarian Ivan Edelman, and supervisor Joe Rachsford. Former Kings County supervisor Joe Hammond was also in attendance. (Author's collection.)

In the late 1980s, a state prison was built south of Corcoran, more than doubling the official population of the city. The prison is divided into two units: Corcoran I for high-security inmates and Corcoran II for others. Officially called the Protective Housing Unit, Corcoran I houses such notorious criminals as Juan Corona, Sirhan Sirhan, and Charles Manson. (Courtesy Kings County Library.)

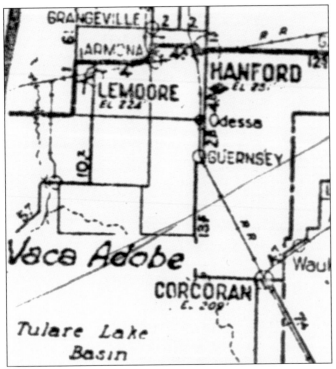

South of present-day Hanford and centered around the intersection of Kansas and Tenth Avenues lies an area still known as Lakeside; a school by that name still operates in that area. Part of Lakeside is a small community called Guernsey, named not for the cow breed but for the local pioneer family who owned the land on which the Guernsey railroad depot was located. Montgomery L. Short operated a store in Guernsey and served as postmaster for several years. Caryl Church, one of the early residents, settled there in 1878. The Valley Railroad built its line through the area and situated a shipping point there. (Courtesy Kings County Library.)

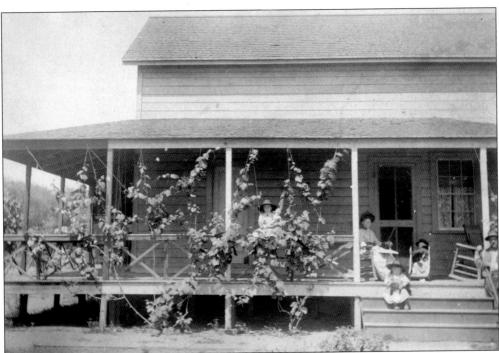

To the west of Lakeside-Guernsey runs the Lone Oak ditch. This photo of Lone Oak farm was taken on May 28, 1893, just five days after the formation of Kings County. On the porch, from left to right, is the Fisher family: Irona, Lana, Florence, Henry, and George. (Courtesy Hanford Carnegie Museum.)

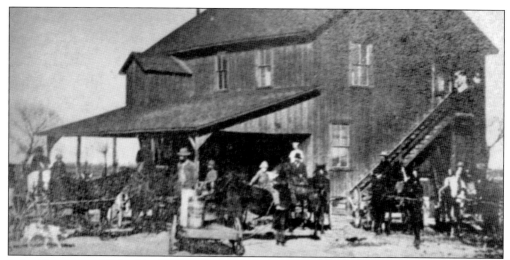

Lakeside was established in 1897 and included a cooperative cheese factory, shown here in a photograph taken that year. The factory was located on the T. E. Howes ranch and was organized in 1893. Lakeside was named for its proximity to the shores of Tulare Lake. Among its founders were Robert Doherty; Charles Kimble; John and William Rourke; John Thomas; Pat McCarthy; Henry Hildebrand; William Stewart; J. M. Moore; and the Howe brothers, Fred and Frank. Prior to that, the Lakeside irrigation ditch, completed in 1873, was about the only thing that existed in the vicinity. (Courtesy Hanford Carnegie Museum.)

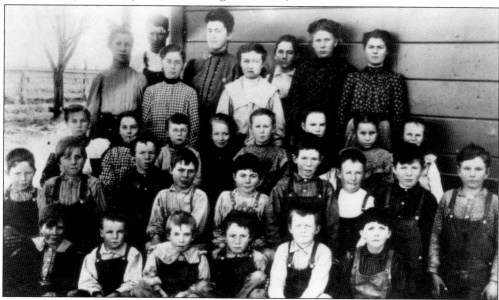

The entire staff and student body of Lakeside School poses for this 1906 portrait. According to what was written on the back of the image, from left to right are (first row) Clarence Furman, Jess Denham, James McCarthy, Harry Harrison, Willie Frasier, and Roy K. C. Meadows; (second row) Forrest Howes, George Stewart, Larry Morrison, Nelson Meadows, Fred Meadows, Frances McCarthy, Verner Denham, John McCarthy, and Elmer Furman; (third row) Hannah Welton, Alta Dibble, Ethel Barden, Grace Stewart, Lucy Harrison, Gertrude Denham, and Lydia Harrison; (fourth row) Mabel Flory, Ulner Denham, Ella Dibble, Lydia Dawson, Susie Howells, Harold Worley, Ella Furman, and Ellen Meadows. (Courtesy Kings County Museum.)

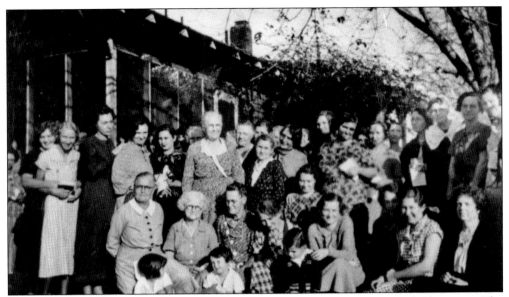

The Lakeside Ladies Aide is shown in this *c.* 1910 photograph taken around Christmas. The group was organized in the summer of 1906 at the home of Hazel Winslow, with Annie Howe as its first president. This photograph was donated by Mark Howe, a descendant of one of the founders of Lakeside. (Courtesy Kings County Library.)

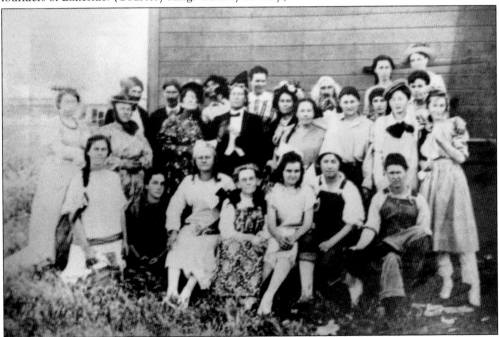

Cast members in costume pose prior to a performance of a play outside the Guernsey Hall in May 1916. The Guernsey Hall Association was formed on October 2, 1902, for the purpose of establishing and maintaining a community facility. The hall was used for meetings, plays, dances, and other community events. In 1954, the 32-year old building was moved to Tenth and Kent Avenues and refurbished for use by the Lakeside Community Church. Guernsey was established as a railroad depot in 1889 with Eli Best as the station agent. (Courtesy Kings County Museum.)

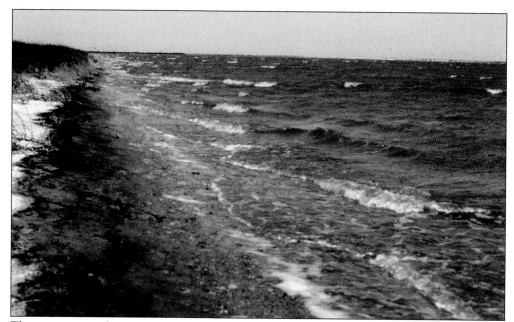

There is no oceanfront property in Kings County, but those living on the shores of Tulare Lake might be excused from thinking otherwise, as this photograph from 1997 shows. Taken during one of the last times the lake flooded, this dramatic image captures a little bit of what the lake was like in its historic heyday. Early residents recount that the full lake had a tide that changed several feet each day. (Courtesy Kerry Arroues.)

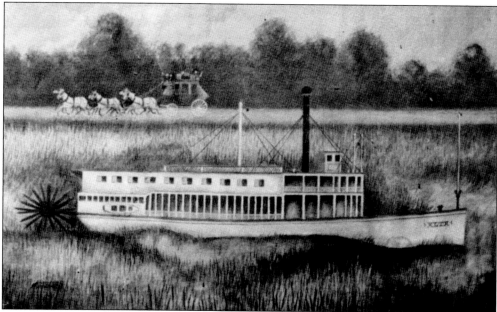

Tulare Lake was the dominant geographical feature of the lower San Joaquin Valley. When full, it was the largest freshwater lake in the western United States. Though never more than about 40 feet deep at its deepest, it was large enough that boats plied its surface carrying passengers and freight. One such boat was the *Alta*, a paddle wheeler that traveled from San Francisco to the lake carrying a number of passengers on its cruises. (Courtesy Hanford Carnegie Museum.)

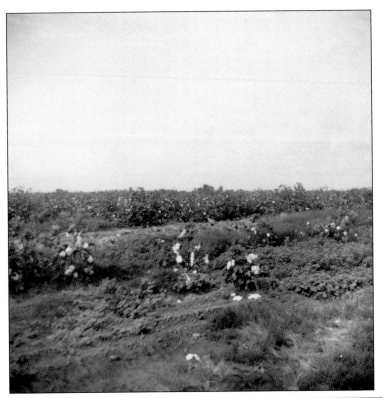

Today the historic Tulare Lake bed comprises some of the finest farmland in the world. One of the largest crops grown in Tulare Lake soil is cotton, as illustrated in this photograph taken in 1938 or 1939. Farming the Tulare Lake bed means constantly coping with the natural forces that seek to re-water the lake (see pages 66 and 67). Despite the risks, the world's largest farms are located here and produce crops worth about $9 billion annually. (Courtesy Hanford Carnegie Museum.)

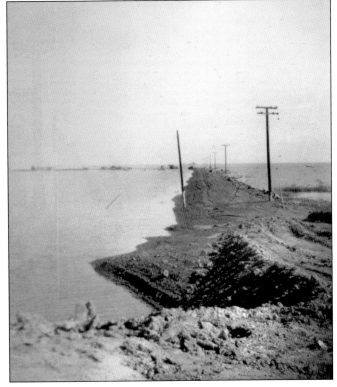

Tulare Lake is barely kept at bay, as is illustrated in this photograph of the 1937 spring flood. A series of levees protect the land but often are unable to cope with particularly large discharges of water from the Sierra Nevada. The lake is the natural terminus for the Kings, Kern, Tule, and White River watersheds in the Sierra Nevada and numerous small seasonal arroyos and year-round creeks and streams in the Coast Ranges. (Courtesy Hanford Carnegie Museum.)

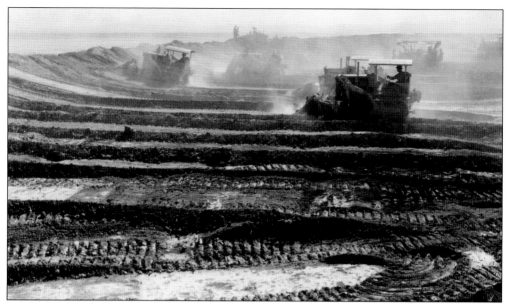

The levees that restrain the Tulare Lake floodwaters and protect the multibillion-dollar agricultural interests are maintained by fleets of caterpillar tractors like those pictured here. The earliest reclaimers, such as Elmer von Glahn, used mule- and horse-drawn implements to build and maintain the levees and dikes. The first steam-powered tractors appeared around 1901 (see page 35). (Courtesy Hanford Carnegie Museum.)

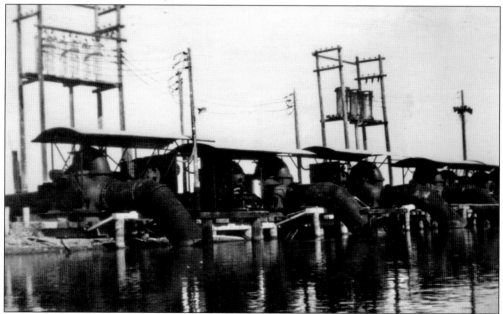

Massive pumps drain the floodwaters of Tulare Lake after the devastating 1937 flood. Four-foot waves broke through levee after levee, the spring runoff swelled the already-massive lake, and water poured over the top of 8-foot levees. The 1937 lake eventually covered 140,000 acres—223 square miles—and crop damage was estimated at $7.5 million (about $86 million today). As a result of this devastating flood, the federal government decided to build the long-postponed Pine Flat Dam. (Courtesy Kings County Museum.)

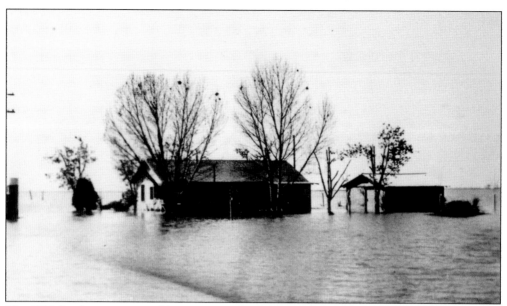

The 1937 flood was a memorable one in many respects. Crockett and Gambogy lost millions of dollars in crops, as did Boswell. It catapulted Elmer von Glahn into the ranks of elite farmers. His land was positioned perfectly: far enough from the lake not to be flooded but close enough to get all the free irrigation water he needed. Other farmers paid him to let them drain water off their land onto his. Not to be outdone, J. G. Boswell bought the entire Cousins ranch while it was underwater—for pennies on the dollar—and then sold the water off at $10 an acre-foot. (Courtesy Kings County Museum.)

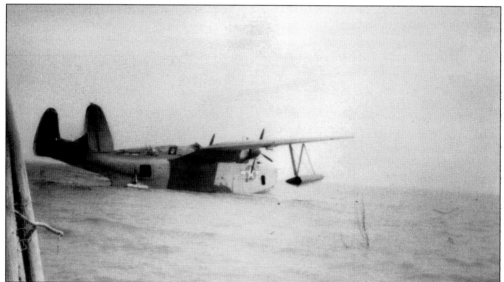

The 1937 flood was followed by a big water year in 1938, and the lake lasted through World War II. The U.S. Navy established a seaplane base on the lake quite by accident. A flight of PBY spotter planes en route to Alameda Naval Base in 1943 was diverted to Los Angeles because of fog. They found themselves over Tulare Lake. Lost and low on fuel and surprised to see a large body of water, they decided to land (see page 42). (Photograph donated by Jack Stone, courtesy Kings County Library.)

Four

THE WESTSIDE, AVENAL, AND KETTLEMAN CITY

Since ancient times, native Californians have known about and used tar and oil for waterproofing and fuel. Just a few miles from Avenal on Reef Ridge is a canyon containing a tar seep that humans have been visiting for thousands of years. Some of the first oil wells in the world were drilled near the seep around 1900, including one using a wooden shaft in what has since become called Tar Canyon. This photograph was taken in October 2007; the location of the seep is currently owned by the Sagaser Ranch southwest of Avenal. (Courtesy Kerry Arroues.)

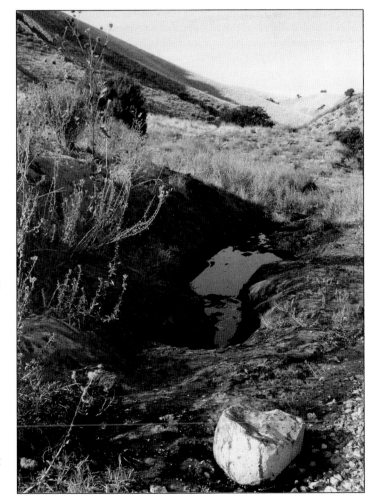

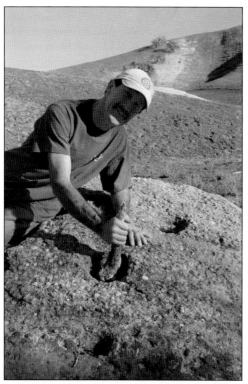

Native Californians maintained only a seasonal presence in the Reef Ridge area but one that persisted for many years, as evidenced by this grinding rock in Tar Canyon. In this 2008 photograph, Hanford pharmacist Lee Pritchard demonstrates the proper use of the mortar and pestle. Tar Canyon is also well known for its abundant fossils. Les Sagaser, a school bus driver in Avenal, retired to a shack at the head of Tar Canyon for prolonged periods of contemplation, prayer, and Bible study. Leo's shack was torn down in the early 1990s, but a cross outside the cabin still stands. (Author's collection.)

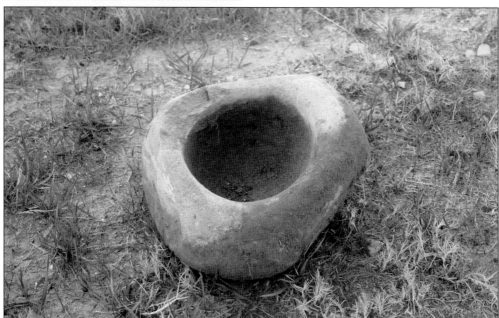

This native Californian mortar was discovered in February 2008 by biologist Tim Schweizer on a research trip with the author and soil scientist Kerry Arroues to Tar Canyon in Reef Ridge. The mortar was damaged by recent road grading, so it was reburied at a safe location, and both the original location and the new location were documented. Artifacts such as this are not uncommon in Tar Canyon, which has been frequented by humans for thousands of years. (Author's collection.)

Early European residents on the Westside included John Cahill and Jim Welch, who built this barn, now known as the Avenal Adobe, in 1852 in Sunflower Valley (originally McClure's Valley). Metal fittings were unavailable, so the rafters were tied using rawhide strips. Ruins of Spanish and Mexican adobes dotted the hills and canyons of Reef Ridge, Pyramid Ridge, and the Kettleman Hills. Both Joaquin Murrieta and Tiburcio Vasquez reportedly took refuge in the adobe. Today it is a private museum. (Courtesy Kings County Museum.)

This drawing of the Avenal Ranch in 1889 by Buck Nimy is titled "Forty Miles from Everything." The Avenal Adobe was built on the site of a prehistoric village along a path used by both native Californians and Europeans. The original house was built of redwood hauled from the Santa Cruz. Cabel Strong Merrill owned the ranch after Cahill and Welch. It was purchased by a group interested in oil that included Roberson and Rawlins of Hanford; they leased it to Miller and Lux and later to the Hays Cattle Company, which was partially owned by members of the pioneer Kreyenhagen family. (Courtesy Hanford Carnegie Museum.)

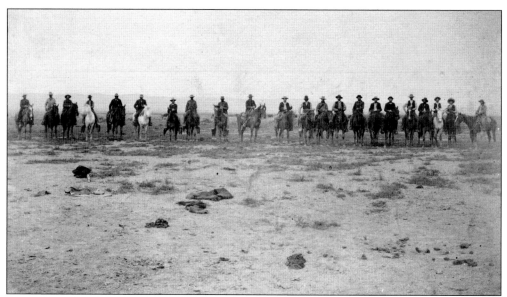

Cattle ranching was the major industry and a way of life on the Westside. These vaqueros pause from their herding duties long enough to have their portrait taken in 1875. Their charges can be seen in the background. (Photograph donated by Georgia Brooks, courtesy Kings County Museum.)

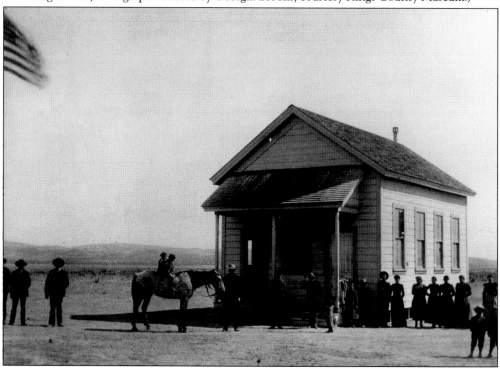

Washington School served the Westside beginning in April 1889. The district encompassed the area east of Avenal down to the Kern County line and included most of Sunflower Valley, the Kettleman Hills, and the southwestern quarter of the Tulare Lake—a huge area and far too large for many students to walk to school on foot. By 1901, the school had been discontinued, very likely a victim of the size of the district it could not adequately serve. (Courtesy Kings County Library.)

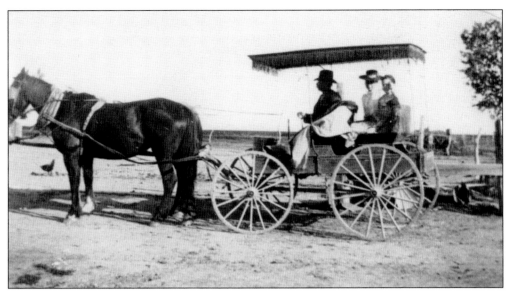

This photograph of Joe Orchard and family was taken by Joe's daughter Elizabeth ("Bess") in 1890 using a Brownie camera. Joe homesteaded near Dudley in 1885 and delivered the mail on the Westside starting in 1888. His route stretched from Huron in Fresno County to Cholame in San Luis Obispo County. According to notes Bess included on the back of the photograph, the Thomasens were the postmaster family in Dudley (in Sunflower Valley) and the Mourenos in Huron. (Photograph donated by Joe Orchard, courtesy Kings County Library.)

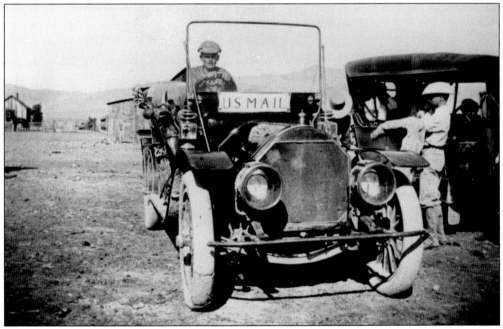

By 1910, Joe Orchard's son Ed was handling the mail, but he used this Pierce Arrow automobile to speed up the service. The Orchard family lived in Dudley, where the post office was located. In addition to the post office and the school, Dudley had a store—all three have long since disappeared, but descendants of the Orchard family still live on the family homestead. (Photograph donated by Joe Orchard, courtesy Kings County Library.)

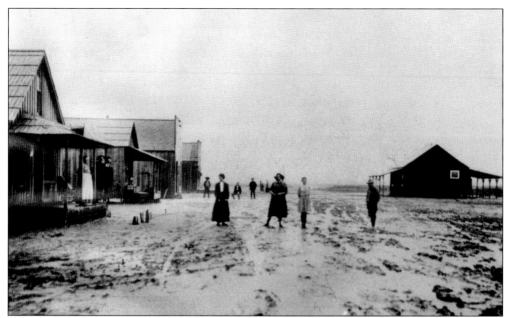

Just outside the southern boundary of Kings County is Devils Den, so named for a curious volcanic formation in the southern end of Pyramid Ridge. It has been associated with the west end of Kings County for years, not because of its geographical location but because of its similarity to other isolated west-end towns, such as Avenal and Kettleman City. This photograph captures main-street Devils Den in 1910, before the oil field sharing its name was discovered. (Photograph donated by Jack Stone, courtesy Kings County Library.)

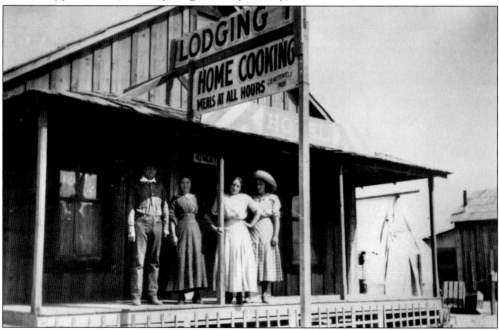

Devils Den had a restaurant/hotel owned and operated by J. Battenfeld, probably the man standing on the left. Taken around 1910, this photograph captures local "ladies of the night" posing outside the boardinghouse in Devils Den. (Courtesy Kings County Library.)

In another view of the hotel in Devils Den, captured some years after the previous photograph, guests include women and children. (Courtesy Kings County Library.)

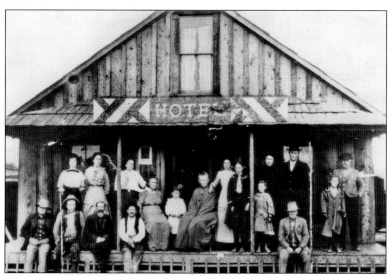

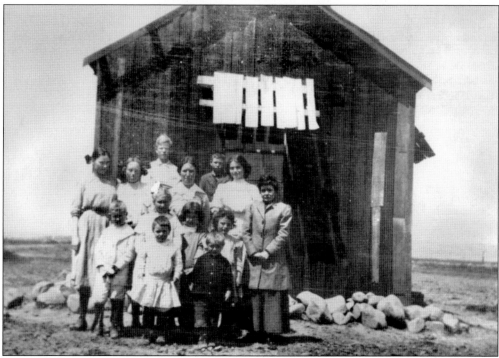

The first school in the Avenal School District (formed June 8, 1887) was this schoolhouse in Sunflower Valley, an abandoned 14-by-16-foot homesteader's cabin in Dudley on L. Merrill's property. It was moved to the Orchard ranch, and a widow with several school-age children taught in order to bolster the enrollment enough to prevent the school being shut down by the county superintendent. In front of the school they are identified as (first row) a nephew of teacher Anne James, Josephine Orchard, nephew of the teacher, and Berry ?; (second row) niece of the teacher, Helen Eileen Orchard King, and Anne James; (third row) Mary Ellen Sullivan Carillo, Gertrude Esther Orchard McGuire, Lowell Heriford, Alma Heriford Silva, William Flynn, and Margaret Orchard Melbase. Joe Orchard and his wife were two-thirds of the school board and the landlords. (Courtesy Hanford Carnegie Museum.)

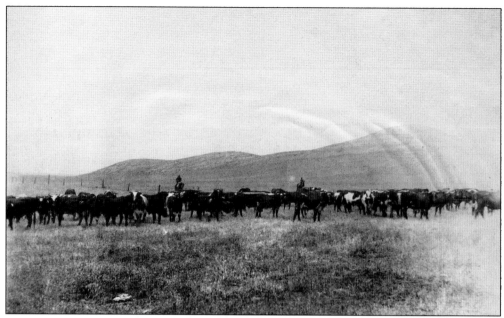

This interesting photograph of cowboys herding cows on the Westside in 1914 shows that not much had changed in the 40 years since the photograph of vaqueros on page 80 was taken. Close inspection reveals that the cowboy on the left is geared using the more American Texas cowboy rig rather than the traditional California vaquero gear, such as the cowboy on the right is using. (Courtesy Kings County Museum.)

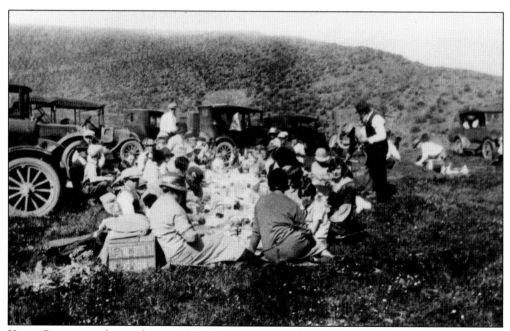

Kings County residents often picnicked on Cottonwood Pass along what is today Highway 41, either as a day outing or as a stop on the trip to the coast. This photograph appears to record a group of families out for a day auto trip. (Courtesy Kings County Museum.)

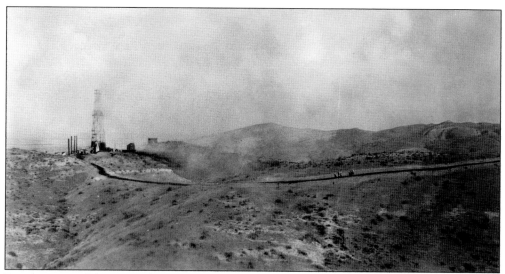

Development of the Westside did not really progress until the discovery of oil in the Kettleman Hills on October 5, 1928. Pictured here is a Millham Exploration Company gasser (an oil well that produces natural gas) in the Kettleman Hills oil field prior to the discovery of oil. (Courtesy Jay Clark.)

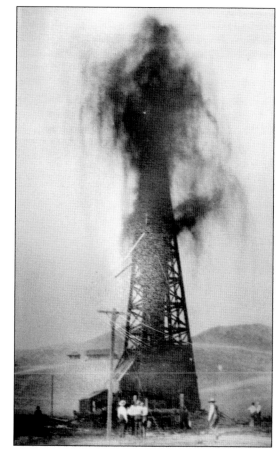

This is another gasser in the Kettleman oil field. Although geologists had long ago determined that the Kettleman Hills held oil, the technology to exploit it did not exist. Conventional cable drills were capable of drilling down to a maximum of about 4,000 feet. When oil was finally struck, it was at approximately 10,000 feet. (Courtesy Hanford Carnegie Museum.)

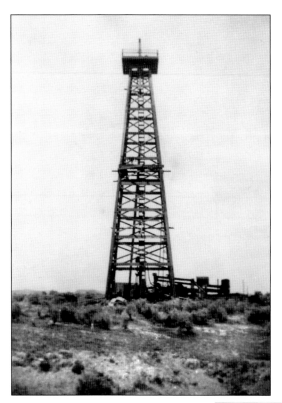

The invention of the rotary drill and other associated technological improvements led the Millham Exploration Company to vow to "drill to China, if necessary" to reach oil. A number of unproductive wells, such as the one in this photograph, were drilled in an effort to locate a producing well. (Courtesy Hanford Carnegie Museum.)

This is the well that started it all: the Millham Discovery Well Elliot No. 1. On October 5, 1928, this well exploded with a roar heard 20 miles away, gushing oil at such a rate that it took 23 days to bring it under control. The well produced a flow of "almost pure gasoline," according to text that came with the photograph. This shot dates from after the well was retired but before it was dismantled. (Standard Oil photograph, courtesy Kings County Museum.)

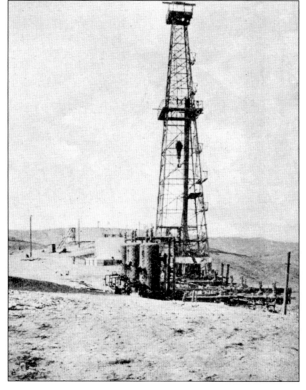

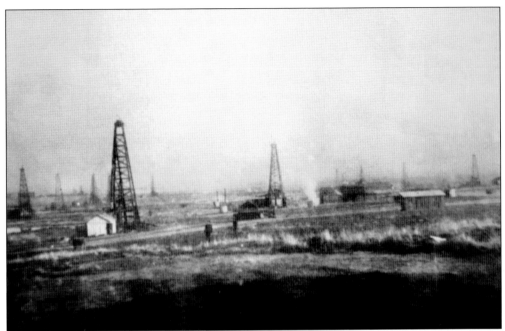

With oil located, the field was rapidly developed. This photograph shows the Kettleman oil field in 1929, just a few months after the Millham discovery in October 1928. Development and exploitation of the oil required masses of workers, all of who needed housing, board, and something to spend their money on. (Courtesy Jay Clark.)

The Millham Exploration Company decided to capitalize on the influx of workers, most of whom were living in tents or other makeshift accommodations. The company laid and platted a city and advertised lots for sale. This advertisement appeared in the *Hanford Sentinel*, and several lots were sold and a few houses built, but the town never really took off. (From *Hanford Sentinel*, courtesy Kings County Library.)

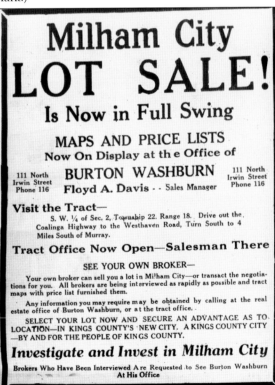

Milham City
LOT SALE!
Is Now in Full Swing

MAPS AND PRICE LISTS
Now On Display at the Office of

111 North Irwin Street Phone 116 **BURTON WASHBURN** 111 North Irwin Street Phone 116

Floyd A. Davis - - Sales Manager

Visit the Tract—
S. W. 1/4 of Sec, 2, Township 22. Range 18. Drive out the Coalinga Highway to the Westhaven Road, Turn South to 4 Miles South of Murray.

Tract Office Now Open—Salesman There

SEE YOUR OWN BROKER—

Your own broker can sell you a lot in Milham City—or transact the negotiations for you. All brokers are being interviewed as rapidly as possible and tract maps with price list furnished them.

Any information you may require may be obtained by calling at the real estate office of Burton Washburn, or at the tract office.

SELECT YOUR LOT NOW AND SECURE AN ADVANTAGE AS TO LOCATION—IN KINGS COUNTY'S NEW CITY. A KINGS COUNTY CITY —BY AND FOR THE PEOPLE OF KINGS COUNTY.

Investigate and Invest in Milham City

Brokers Who Have Been Interviewed Are Requested to See Burton Washburn At His Office

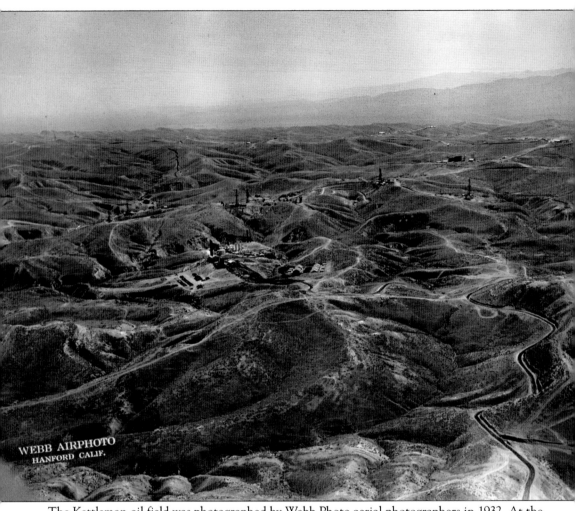

The Kettleman oil field was photographed by Webb Photo aerial photographers in 1932. At the time, production was in full swing, and the fields were literally growing week by week. The view is looking southwest. (Courtesy Kings County Museum.)

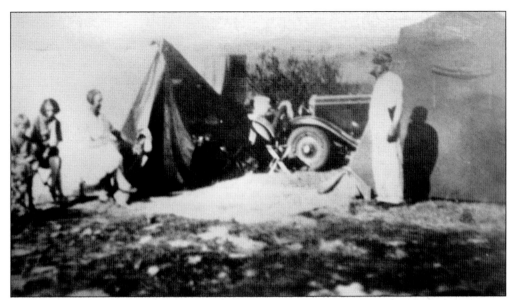

The first oil field workers lived in tents, even those that brought their wives and children with them. Recognizing the need for adequate housing, Standard Oil surveyed a town site and began constructing homes. That town was named Avenal (Spanish for "wild oats"), and the year of its conception was 1929. (Photograph donated by Minola Ayers, courtesy Kings County Library.)

The first business in Avenal was not established by the Standard Oil Company: Arthur Allen received permission from Standard Oil to construct a metal shed on Highway 33 and opened Paco's Welding Shop. George Koepp actually ran the business and lived in the shop with his wife, Ethel, beginning in the spring of 1929—thereby becoming the first two residents of the city of Avenal. (Photograph donated by Velma Morris, courtesy Kings County Museum.)

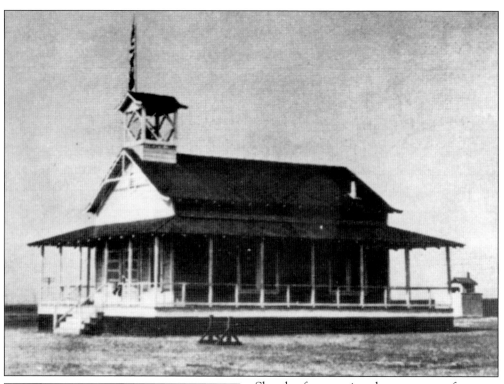

Shortly after opening the new town of Avenal, Standard Oil moved this building from an oil camp near Coalinga to its new location at the current Avenal Elementary School site, and school has been held at that location, although in different buildings, since that time. (Photograph donated by Minola Ayers, courtesy Kings County Library.)

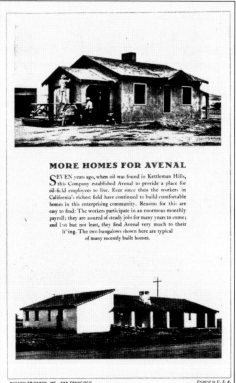

MORE HOMES FOR AVENAL

SEVEN years ago, when oil was found in Kettleman Hills, this Company established Avenal to provide a place for oil-field employees to live. Ever since then the workers in California's richest field have continued to build comfortable homes in this enterprising community. Reasons for this are easy to find: The workers participate in an enormous monthly payroll; they are assured of steady jobs for many years to come; and last but not least, they find Avenal very much to their li'ing. The two bungalows shown here are typical of many recently built homes.

MCCANN-ERICKSON, INC., SAN FRANCISCO Printed in U. S. A.

At first, residents were allowed only to rent the homes in Avenal. Later Standard Oil sold them. In January 1936, Standard Oil ran this advertisement in its magazine, hoping to entice more workers to its old fields with the lure of new homes. Avenal boomed during the Depression, reversing the nationwide trend. The peak year for oil production was 1938. (Courtesy *Standard Oil Bulletin*.)

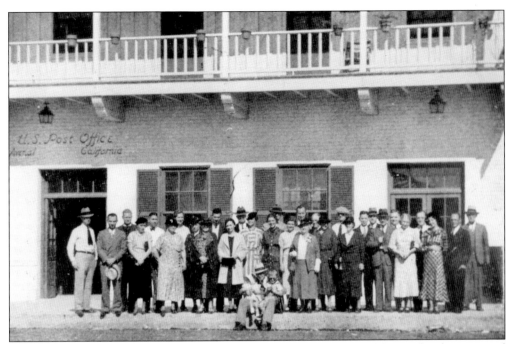

A new post office building for Avenal was dedicated in 1936. Standard Oil designed and constructed the building, paid for it, and even assigned some of its employees to attend the dedication, which was captured in this photograph. A public library was housed on the second floor. (Standard Oil Company photograph, courtesy Kings County Library.)

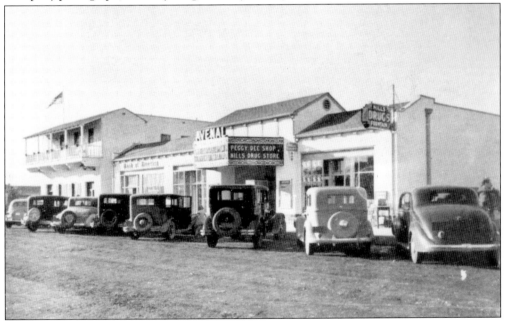

Commercial development of Avenal was controlled by Standard Oil, which constructed and sold the buildings in this 1936 photograph. In addition to the post office/library building (far left), a Bank of America branch was opened, a movie theater premiered on October 19, 1935, and Mills drugstore opened for business. (Standard Oil Company photograph, courtesy Kings Count Library.)

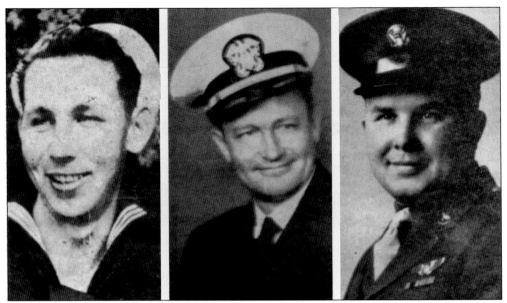

During World War II, Avenal sent its young men to serve, and three individuals stand out: Coxswain Henry Baker Jr., USN (left), died aboard the USS *Pennsylvania* during the attack on Pearl Harbor that opened the war. Lt. Comdr. Donald Elton Carter, USNR (center), also known as "Carter the Lucky," commanded LST 358, the "Lucky 385," so called for its close calls during landings at Sicily, Salerno, Anzio, and Normandy. S.Sgt. Walter F. McCaleb, USAAF (right), was the ground crew chief for the *Enola Gay*. (Photographs from *Avenal at War*.)

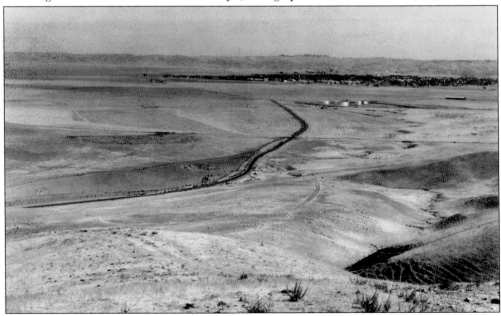

This view looks north across Sunflower Valley to the Kettleman Hills with the city of Avenal in the distance. The photograph was taken on September 28, 1966, by USDA Soil Conservation Service scientist Carl H. Anderson of Hanford. At the time, Avenal was the second largest unincorporated population area in California. After two unsuccessful attempts, Avenal incorporated as a city on September 11, 1979. (Courtesy USDA Natural Resources Conservation Service.)

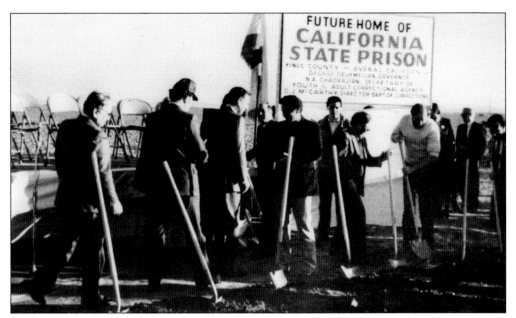

On December 18, 1985, a new day dawned in Avenal: ground-breaking for a new (and controversial) California state correctional facility took place. Participating in the ceremony were Daniel J. McCarthy, director of the State Department of Corrections; Rodney Bloncon, undersecretary of the Youth and Adult Correctional Agency; Rep. Robert Presley (D-Riverside), chairman of the Joint Legislative Commission on Prison Construction; the Kings County Board of Supervisors; and various Avenal city officials. (Gary Feinstein photograph, courtesy Kings County Library.)

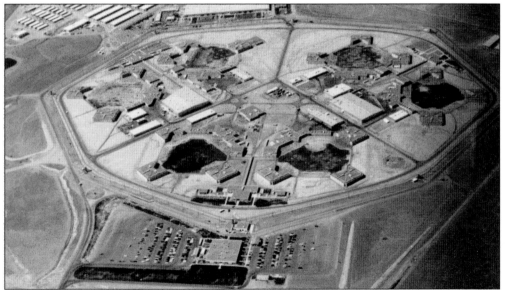

The prison was dedicated on April 29, 1988, the first new prison built in California since 1962. The 240-acre location was annexed as part of the city, doubling its population almost overnight once inmates started arriving. The first nine inmates arrived at 6:30 p.m. on January 17, 1987, to work on fire and kitchen crews, with 38 more coming the next morning. Avenal State Prison was in business, and the city of Avenal experienced new life. (Courtesy Avenal State Prison and Kings County Library.)

A local landmark known to many residents of Avenal was this water tank constructed from a military surplus aircraft wing fuel tank. It was painted bright yellow and located along the Tar Canyon road. Taking a ride on the Tar Canyon "Yellow Submarine" are Barbara Hughes and Kerry Arroues of the USDA Soil Conservation Service (now Natural Resources Conservation Service) in 1980 while completing the Kings County soil survey. The tank has been removed; in 2008, only a few remnants remain. (Courtesy Kerry Arroues.)

Avenal Creek, pictured in January 1960 on the Newton Ranch, flowed along the western edge of Reef Ridge and is the last major waterway before reaching the Monterey County line. It is overlooked by the Table Mountains in the background. (Photograph by Carl H. Anderson, courtesy USDA Natural Resources Conservation Service.)

On the opposite (east) side of the Kettleman Hills from Avenal, overlooking the Tulare Lake basin, are the Kettleman Plains, shown on October 20, 1971. In the middle distance are cotton fields and, on the horizon, the Sierra Nevada. As was true historically, there are very few if any trees and little appeal to potential settlers. A scene similar to this greeted the first residents of the Kettleman Plains. (Photograph by Carl H. Anderson, courtesy USDA Natural Resources Conservation Service.)

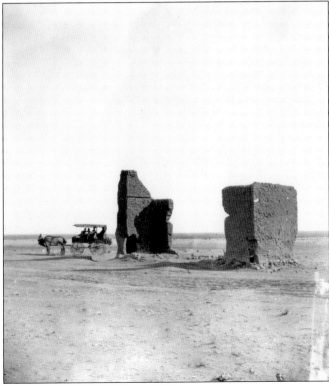

In this well-known 1893 photograph, the Kreyenhagen family (in the carriage) visits Steamboat Landing and the "Double Adobe," the remains of an adobe structure built by Cox and Clark. The family was returning to Hanford from a summer vacation at Pismo Beach. Located about 3 miles south of Kettleman City, the adobe was situated where El Camino Viejo ("the old road") from San Pedro to San Antonion (East Oakland) ran closest to Tulare Lake, in the distance. Traces of the old road can be seen in the foreground. (Photograph by the Kreyenhagen family, courtesy Hanford Carnegie Museum.)

Land on the Westside was opened to homesteading and development after World War I. In 1929, A. Manford Brown of Morro Bay bought 320 acres from pioneer Claude Friend and subdivided it, naming the subdivision Kettleman City. He set aside land for a school and a church, both of which are used for those purposes today; drilled a water well; and laid gas, water, and electrical service lines. Kettleman City was named for David Kettelman, who grazed his cattle in the area where the city lies today. (Courtesy *Standard Oil* magazine.)

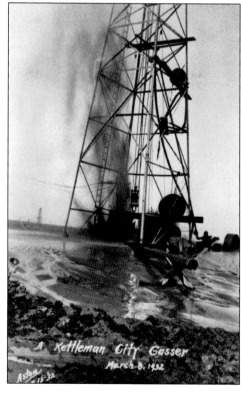

Brown's interest was to capitalize on the oil boom in the Kettleman Hills by providing convenient services to workers in the field on the east slope of the hills. He owned his own oil well, pictured here in March 1932. Kettleman City appealed to workers, who preferred it to the Millham City location (see page 87) or Avenal. (Photograph donated by Marian Tuck, courtesy Kings County Library.)

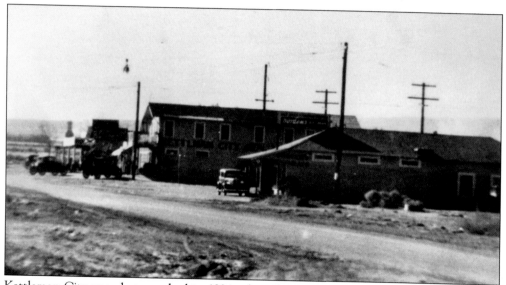

Kettleman City was photographed in 1934, when the town was less than four years old. The plat map for the town was approved by the Kings County Board of Supervisors on February 15, 1929, and the town was situated on Highway 41 about 1 mile from the Spreckels Sugar Company Ranch. (Courtesy Kings County Library.)

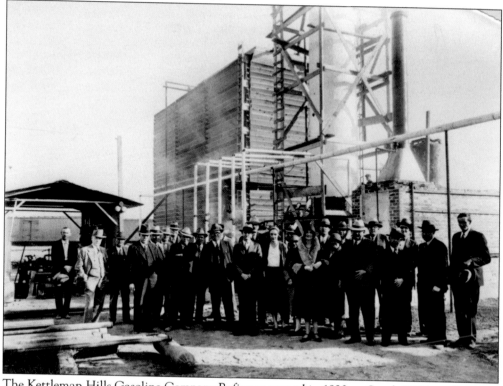

The Kettleman Hills Gasoline Company Refinery opened in 1930 on South Williams Street in Hanford. It was purchased by the Caminol Company in 1932 to refine crude oil from the Kettleman Hills. Caminol later became Beacon Oil Company, which was purchased by Ultrmar Oil in the 1980s. The refinery closed down and was dismantled in 1990. (Courtesy City of Hanford.)

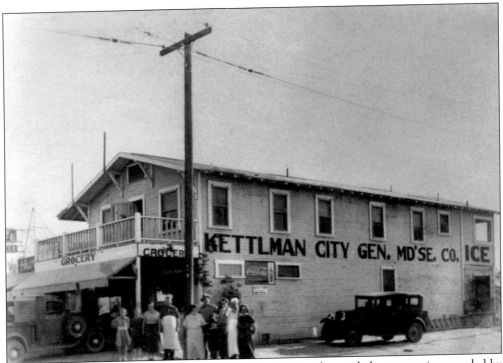

Bill Dean's General Merchandise store was built in 1930 and provided most services needed by residents and passersby. It was located at the corner of Highway 41 and General Petroleum Road. (Courtesy Kings County Library.)

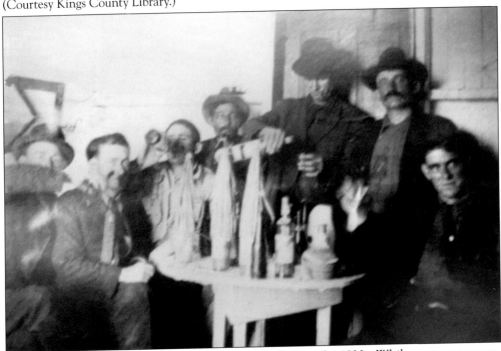

These oil field workers are photographed in Dean's Café in the 1930s. While room was scarce, the liquor seemed to be in good supply. (Courtesy Jay Clark.)

Gladys Dark and Ennis Shankland wait on, among others, Mary Rodabush, Bernice Champlin, and John Shankland in the Kettleman City Store in 1934. A corner of this store served as the first Kettleman City Post Office. (Photograph donated by Clarice Tuck, courtesy Kings County Library.)

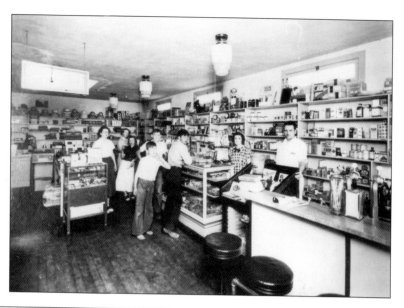

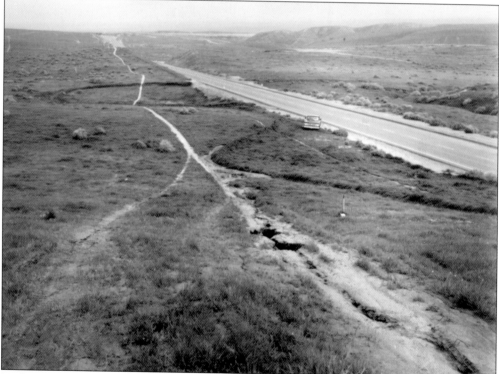

Highway 41 just north of Kettleman City was photographed March 1, 1973, by Carl Anderson of the Soil Conservation Service. This lonely scene was reflective of the long, slow decline that Kettleman City found itself in following the reduction of oil production after World War II. Local farming and the occasional traveler helped keep the town from dying out completely, but its death seemed inevitable until Interstate 5 was completed in the 1980s. Kettleman City became a stop for travelers on I-5 and Highway 43, who injected new economic vitality into the community. (Courtesy Natural Resources Conservation Service.)

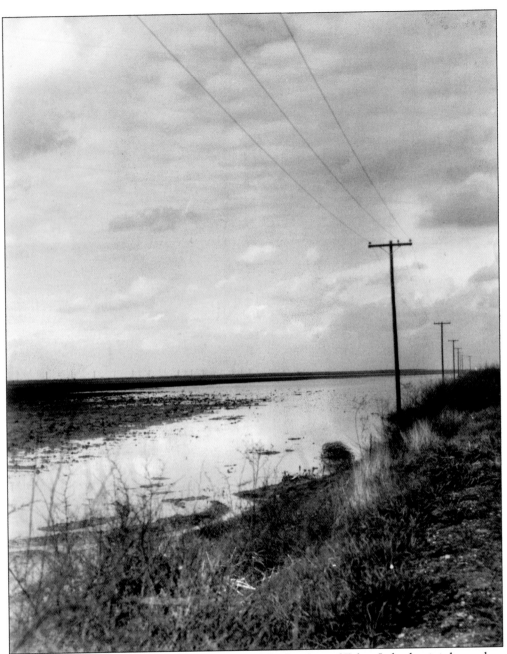

Kettleman City frequently has a bird's-eye view of the flooding of Tulare Lake, but it is located on higher ground so flooding doesn't reach the town itself. It is affected, however, by flooding that closes Highway 41, as this January 1969 photograph shows. To the left is residual water from the floods of 1967–1968. Just a short time after this photograph was taken, the heaviest snowpack in recorded history started melting, and the lake came back with a vengeance, flooding 80 square miles of the lake basin and leading to armed confrontations between farmers determined that their land was not to be the victim of a neighbor desperate enough to save his own crops by diverting floodwater onto his neighbor's crops. (Photograph by Carl H. Anderson, courtesy USDA Natural Resources Conservation Service.)

Five

ARMONA, GRANGEVILLE, AND KINGSTON

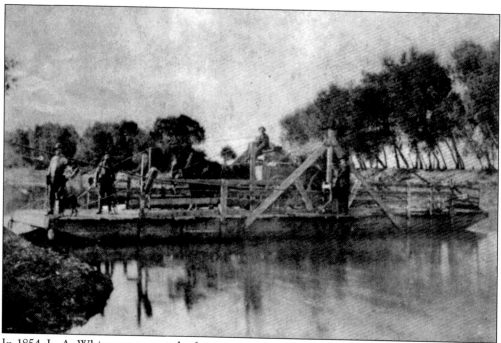

In 1854, L. A. Whitmore operated a ferry across lower Kings River. The town of Kingston grew up around the ferry and was the only town in the Central Valley between Stockton and Visalia for a number of years. The Overland Stage Lines, which later became the Butterfield Line, used the ferry to cross the river and maintained a stage stop there. The town was named for the Kings River, being roughly a contracted version of "Kings Town." It thrived until the main bridge over the Kings River for the road and the railroad was built about half a mile upstream, leading to the creation of Laton. See also pages 49 through 58 in Images of America: *Hanford*. (Courtesy Hanford Carnegie Museum.)

Another early town, Grangeville, was platted by James A. Hackett and Peter Kanawyer in 1874. The town was named in 1871 for the Grange, pictured here. It is the oldest existing community in Kings County. For many years, Grangeville Hall was the community center of the Mussel Slough country, named for the only perennial waterway apart from the Kings River in the area. The Last Chance Ditch and the Peoples Ditch, both completed in 1873, circle the community and provide groundwater seepage that recharges the wells in the area. (Courtesy Kings County Museum.)

This is the Grangeville General Mercantile, photographed sometime after 1896. It stood on the southeast corner of Grangeville Boulevard and Fourteenth Avenue. David Brownstone built the first store in Grangeville in 1872 on the northwest corner of the intersection. The next year, Aaron Tyner built the Mussel Slough Flouring Mill and John Bruner a harness shop nearby. (Photograph donated by Rod Ritchie, courtesy Kings County Library.)

The Grangeville Methodist Episcopal Church on Hackett Street is the oldest church building in the county, constructed in 1878. Since this photograph was taken in 1940, the church has become the property of Kings County, which leases it to the Kings County Historical Society for $1 per year. The church was renovated, and the historic redwood siding was covered with stucco. (Photograph donated by Rod Ritchie, courtesy Kings County Library.)

The Grangeville School is in the Pioneer School District, the oldest continuously operating school district in Kings County, having been created on August 5, 1870. Originally the district covered almost the entire area that later became Kings County. The original schoolhouse was built that year by W. W. Parlin on the northwest corner of Fourteenth Avenue and Grangeville Boulevard (where the Grangeville store is today) and paid for by local subscriptions from the residents. In September 1883, the school moved to its present location two blocks north. (Courtesy Kings County Museum.)

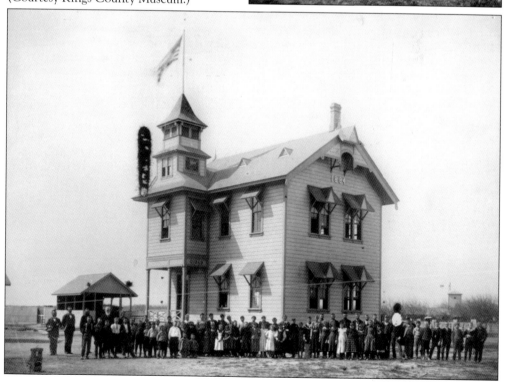

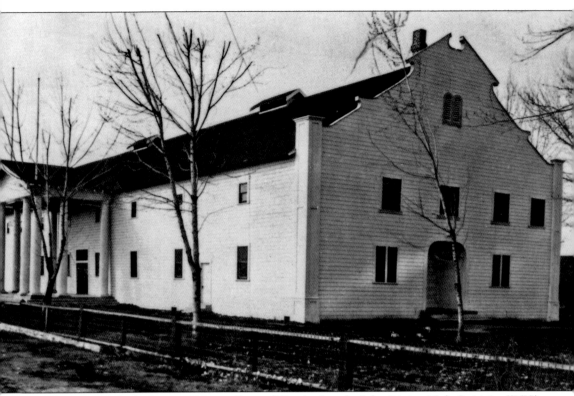

The Irmandade do Devino Espirito Santo ("Brotherhood of the Divine Holy Spirit"—IDES) Hall was added after 1893, representing the interests of the many natives of the Azores in the area. Like Kingston, Grangeville was the victim of unforgiving infrastructure: the Southern Pacific decided to build its rail line 3 or 4 miles south of the town, creating the community of Armona and condemning Grangeville to a barely lingering existence. Recently Grangeville has experienced a surge in population, as several large-scale housing developments have been built within or contiguous to the bounds of the original plat laid out by Hackett and Kanawyer in 1874. (Courtesy Kings County Museum.)

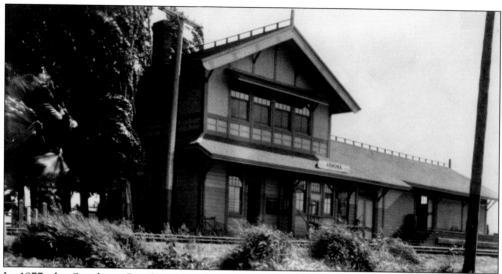

In 1877, the Southern Pacific railroad constructed a rail line from Goshen to the Westside, bypassing Grangeville. That year, John Yoakum laid out Armona next to the tracks for the Pacific Improvement Company, probably naming it after the railroad switch there. The residents of Grangeville, recognizing that the railroad's bypassing of their town spelled its demise, began moving to the new town. By 1887, a small town had developed around the tracks that included MacGregor's hotel and Samuel Young's blacksmith shop. Armona was officially named on March 22, 1887, when the post office was established. M. A. Harding was the initial postmaster. The depot pictured was built in 1891 and photographed in 1911. (Courtesy Hanford Carnegie Museum.)

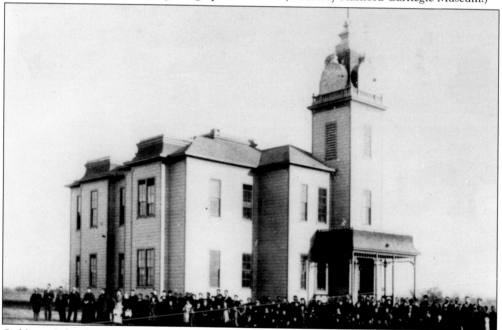

Giddings School was formed on May 14, 1880, and the schoolhouse was built that summer. The school was named for E. E. Giddings, who donated the property. A larger property was later obtained from the Pacific Improvement Group for $1, and the school pictured here was built. The school was renamed Armona in 1907. (Courtesy Kings County Museum.)

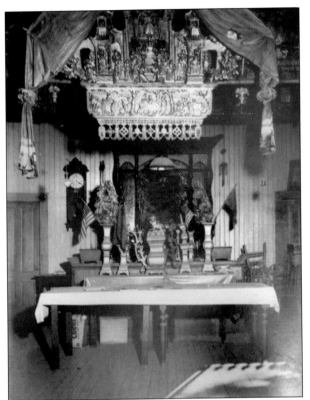

Around the beginning of the 20th century, a Chinatown sprang up in Armona west of Lake Avenue (Fourteenth Avenue). It was the largest in Kings County and second only to Fresno in size. It centered on the temple, whose interior is shown. Across Lake Avenue, a Japanese community sprang up centered around the store and labor contracting business owned by the Tiayo brothers—Frank, Sam, Harry, and George. The Chinese temple stood until 1965, when the entire deteriorating Chinatown area was razed. (Courtesy Jay Clark.)

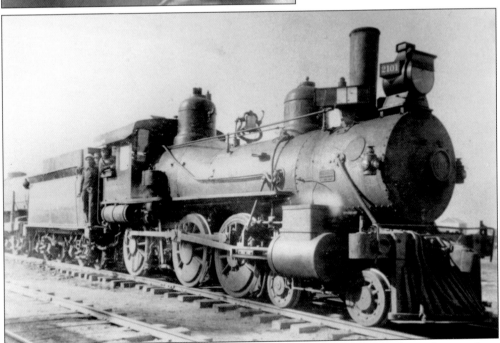

"Old Six Bits" was the nickname given to one particular train engine that made regular runs from Goshen to Coalinga carrying water from Armona, where the water was considered good, to Coalinga, where the water was contaminated with petroleum. (Courtesy Kings County Museum.)

Kenzie Whitten "Blackhorse" Jones poses with an oar while standing on his own ship-shaped tomb. He spent many years creating his own burial plot and stone coffin shaped like the ship of life. He was buried in 1909, and his unique grave site is open to the public, although protected by a locked fence with iron bars. Jones lived on the Westside but chose to be buried in the Grangeville Cemetery. The cemetery was officially established in 1876, though the oldest plot, the Hackett family's, dates from 1867. John Yoakum, who laid out the town of Armona, is buried there, as are several of the casualties of the Mussel Slough tragedy. (Courtesy Hanford Carnegie Museum.)

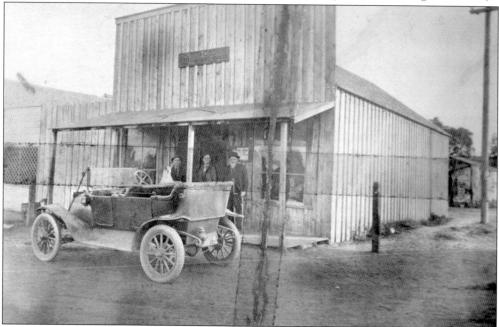

The Ed Rick grocery store, shown here in 1907, featured Red Crown Gasoline, the original gasoline product of the Standard Oil Company. (Courtesy Kings County Library.)

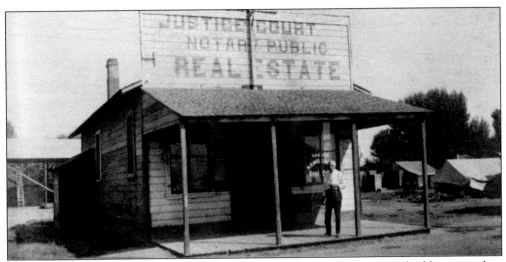

Armona was booming when this photograph of the Community Justice Court building was taken in 1919. (Courtesy Kings County Museum.)

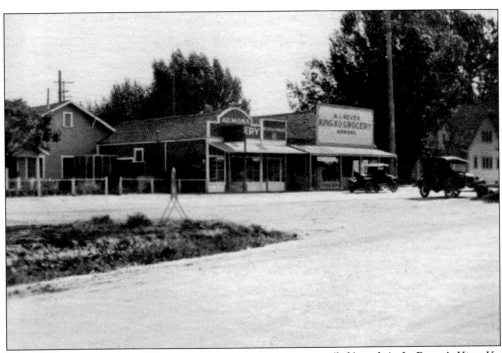

Armona, seen in the mid-1920s, included Armona Creamery (left) and A. L. Reves's King-Ko Grocery. (Courtesy Kings County Library.)

The Armona School orchestra is photographed in December 1941 prior to performing their Christmas concert. The orchestra was directed by Lois Ashton. The members included Walter Dillon, Paul Hames, Vera Griswold, Willa Hobles, Dallas Paden, Harry Davidson, Dorothy Roberts, Jeralee Adams, Barbara Leal, Vivian Bello, Emogene Shetters, Dorothy Goad, Betty Smay, Marilyn Fellers, Adona Hobson, Eleanor Bell, Charles Gillen, and Arnold Brown. (Courtesy Hanford Carnegie Museum.)

Bob Athey is photographed in front of his Standard gas station in the mid-1940s. The logo on the pump to the right of him includes the Standard Oil Red Crown logo. The Chevron logo had not been adopted yet. The prices posted on top of the pumps would be welcome today: 16 9/10¢ and 18 9/10¢ per gallon (including 4 9/10¢ per-gallon tax). (Courtesy Hanford Carnegie Museum.)

This portrait of the workers at Armona Cannery No. 1 was taken in 1941. The 1920s were the peak years for the Armona packinghouses for dried fruit and raisins. Armona grew during the Depression, as workers for the packinghouses migrated from Oklahoma and Texas. About 1940, cotton began to replace the orchards and vineyards that supplied the packinghouses. The last one went out of business in the early 1950s, and Armona became primarily a bedroom community for Hanford and Lemoore. (Photograph donated by Bel Bogan, courtesy Kings County Museum.)

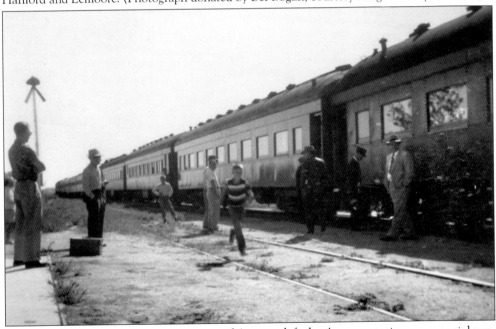

In April 1951, the last passenger train out of Armona left the Armona station on a special run. The same was true for the other cities and stations on the old Southern Pacific line; it marked the end of another era. (Courtesy Hanford Carnegie Museum.)

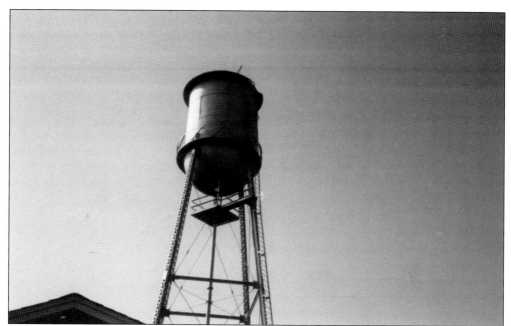

The landmark Armona water tower was photographed for the bicentennial celebration in 1976. During the 1960s, the construction of NAS Lemoore created an influx of families into the Armona area. (Courtesy Kings County Library.)

Danielson's Hardware, photographed in 1976, was known beyond Armona for having a good supply of hard-to-find tools for rent. This photograph was taken as part of the American bicentennial celebration. (Courtesy Kings County Library.)

In 1976, the C. M. Otay Company—the last packinghouse in Armona—was torn down, thus ending another era in Armona. (Courtesy Kings County Library.)

Six

HARDWICK, BURRIS, CROSS CREEK, AND THE ISLAND DISTRICT

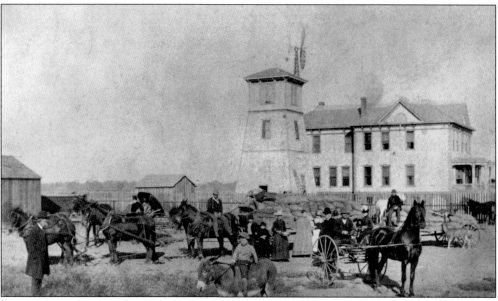

David Burris and family settled in the very northeast corner of what became Kings County in 1857, the same year the Rhodes and Esrey families came to Kings County. All had one thing in common: they settled on the south bank of the Kings River, avoiding the Laguna de Tache Ranch, which owned the bulk of the land on the north side of the river. The house pictured here was built in 1884; this photograph was taken in 1885–1886. It was constructed of redwood and had 14 rooms. In front of the "big house," as the family called it, is a six-mule team set to haul grain to the station at Traver, 6 miles away. David Burris is on the left in the foreground with his hands in his pockets. (Courtesy Hanford Carnegie Museum.)

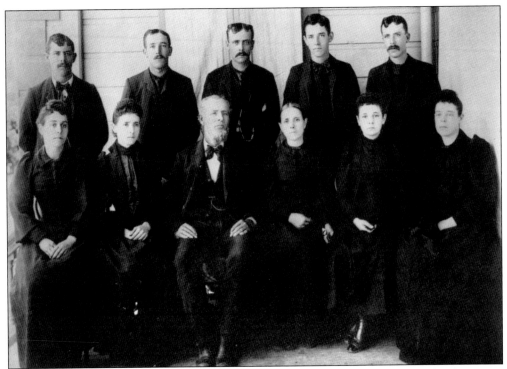

The Burris family, from left to right, consists of (first row) Laura, Mamie, David, Julia, Dora, and Alice; (second row) Edward, Henry, Joshua, Frank, and Walter. The photograph was taken on the day of the funeral for young David Jr., who drowned in a nearby slough on July 20, 1892. (Courtesy Kings County Museum.)

The Kings County Museum at Burris Park opened in 1955. Kings County supervisor C. R. Swanson and his wife donated the building, and the county donated the land at Burris Park. This photograph records the dedication of that building. The park was donated to Kings County by the Burris family some years after the death of David and Julia. (Courtesy Kings County Museum.)

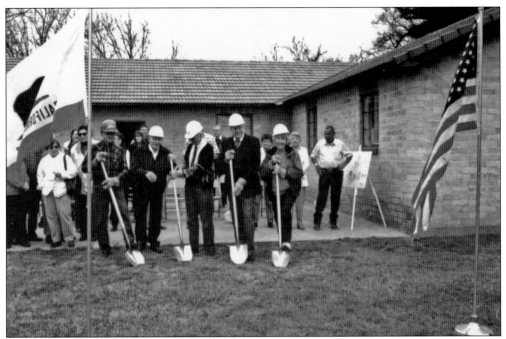

In 1999, ground was broken for a new wing to the existing Kings County Museum at Burris Park. The major donor for the addition was Leonard Hall (far left, with shovel), who made the donation in honor of his wife. The centerpiece of the wing exhibit is the Dr. Frank Griffiths collection of Native American artifacts, purchased for the museum by the Hanford Exchange Club in 1928 for $5,000. The collection waited over 70 years to find a permanent home. (Author's collection.)

Lou Chittenden poses in the rose garden of his residence on the Lucerne Vineyard, the largest vineyard in world under one management at the time—a total of 1,350 acres of grapes were cultivated. Chittenden was the managing partner of Paige, Root, and Chittenden, who owned the vineyard located on the west side of Twelfth Avenue north of Flint. (Courtesy Kings County Museum.)

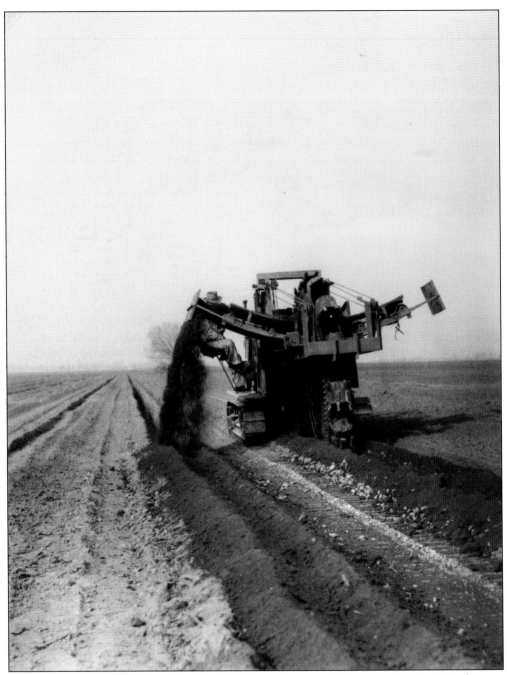

In 1922, M. D. Hopper purchased the Lucerne Vineyard property. The estate is gone; in its place are newer facilities, including a winery. The Hopper family still owns much of it. In 1961, this trencher was photographed deepening the soil profile prior to replanting the old vineyard. (Photograph by Carl H. Anderson, courtesy USDA Natural Resources Conservation Service.)

Cross Creek was the last relay station for the Butterfield stage lines before reaching Kingston. This photograph, taken in 1927, preserves the last remaining structure at Cross Creek, the remains of the second bridge built over Cross Creek. The station was located off the left side of the photograph. Frank Dalton was said to have been sweet on the female station agent at Cross Creek and was reported to have spent a considerable amount of time "hiding out" at the station after his release from prison. (Courtesy Kings County Museum.)

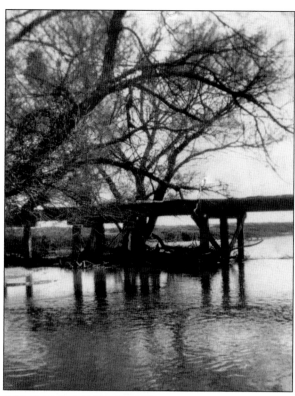

Cross Creek School, which consolidated with King School in 1944, is shown in a photograph by Marjorie Whited Cummins during the 1938–1939 school year. It has been preserved in a scrapbook reporting her activities as a music specialist for that year. The scrapbook is part of the Carnegie Museum collection. (Courtesy Hanford Carnegie Museum.)

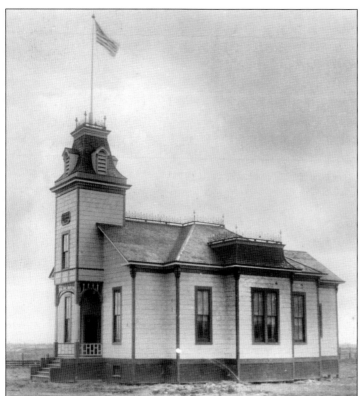

Another photograph taken by Marjorie Whited was this one of Eureka School, which she reports was the oldest school building still in use during the 1938–1939 school year. The Eureka school was formed in 1874 and was located at Fargo and Seventh Avenues, in the immediate vicinity of Cross Creek station. Today a marker commemorating the school can be seen at that intersection. Eureka School unionized with Mid-Valley School to form the Kit Carson School District. (Courtesy Hanford Carnegie Museum.)

A scene reminiscent of yesteryear, this photograph was taken by the author in 2007 at a ranch northeast of Hanford. Kings County still retains much of its rural character, and scenes like this are more common around the county than one might think. (Author's collection.)

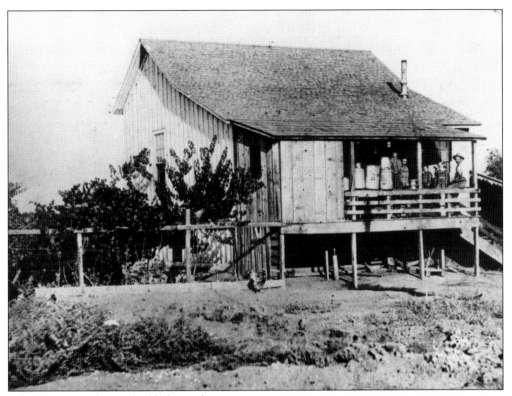

The Giacomazzi home doubled as a cheese cellar for the family dairy. Located on Sixth Avenue, the Giacomazzi Dairy was founded in 1893. Louis Giacomazzi came to Hanford to collect on a loan made to a friend, only to find the friend had used the money to purchase 160 acres, which he later abandoned and left the county. Louis took possession of the land in lieu of the loan repayment and decided to start a dairy. That dairy has now been operated by the family for more than a century. (Photograph donated by the Giacomazzi family, courtesy Kings County Library.)

The small community of Hardwick, north of Hanford, began as a Southern Pacific depot in 1899. Walter Gallup owned the land, his brother leveled it, and Charles King laid out the plat. King later ran for governor; his campaign poster is reproduced here. Hardwick once boasted, in addition to the depot, a meat market, J. E. Moore's store and ice house, a blacksmith, the Hardwick School, a Methodist church, Hewitt's general store, a post office, Hoskins Garage (which also housed the fire department), a lumberyard, a fruit packinghouse, and a creamery. (Courtesy Kings County Museum.)

CHARLES KING
Candidate for the Democratic Nomination for Governor at the Primary Election, Aug. 25, 1914

A little-known episode in Kings County history, the "Battle of Hardwick Bridge," occurred on December 2, 1910. Crews for one railroad took up a position in a house on the west bank of the Kings River immediately west of Hardwick to prevent a competing railroad crew from completing a bridge. The crew crossed the river at night, armed with axes and guns, and chopped the house down around their rivals. A pitched gun battle seemed imminent when the Kings County sheriff arrived with deputies and hauled both crews off to jail. The bridge was built, and both railroads were completed, only to be bought out by a larger railroad and later disbanded. (Author's collection.)

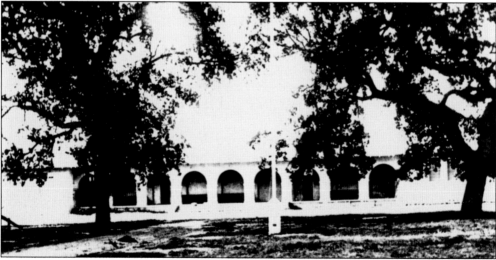

The first school to service the Hardwick area was the Kingston School, which was closed down as Kingston disappeared and renamed Hardwick School in March 1908. It united with the Laton Union School District in 1905 but later consolidated with Kings River School in 1962 to form the Kings River–Hardwick School District. The site of this school is now a Kings County fire substation. (Courtesy Hanford Carnegie Museum.)

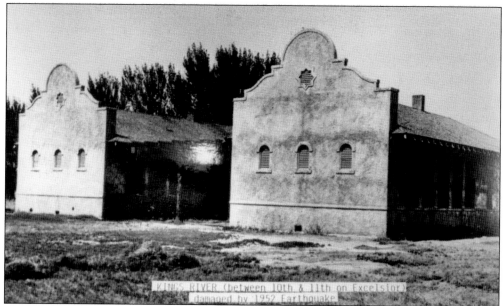

The Kings River School was built on Excelsior Avenue in 1914. On August 5, 1952, an earthquake seriously damaged the already troublesome building. With nowhere else to send the students, citizens and staff propped up the parts of the school less seriously damaged, abandoned the rest, and made do while building a new school. Students moved to the new building, still used today, on March 21, 1956. (Courtesy Hanford Carnegie Museum.)

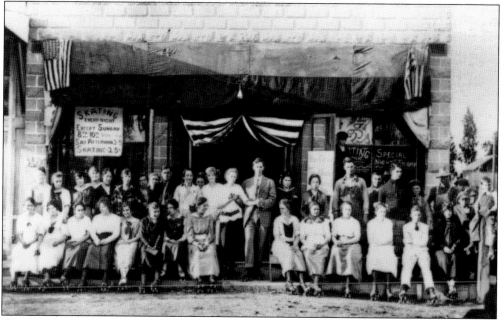

The Hardwick roller skating-rink is shown here about 1918. It cost 25¢ to skate, and the rink was open on Saturday afternoons and every night except Sunday. A sign near the entrance announces "Big Doings To Night 7:30," which may account for both the number of patrons at the rink and the photograph itself being taken. (Photograph donated by Betty Newton, courtesy Kings County Library.)

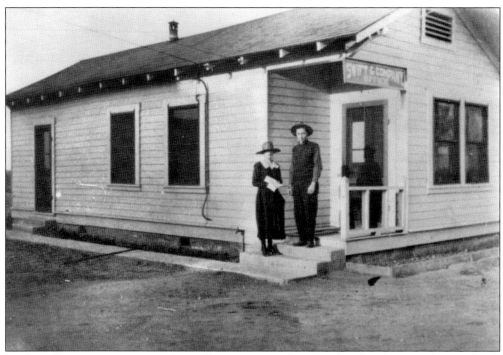

Swift and Company maintained an office just west of Hardwick. The photograph is undated; Katie Kendall and Jerome Miller are on the porch. The two were later married. (Courtesy Hanford Carnegie Museum.)

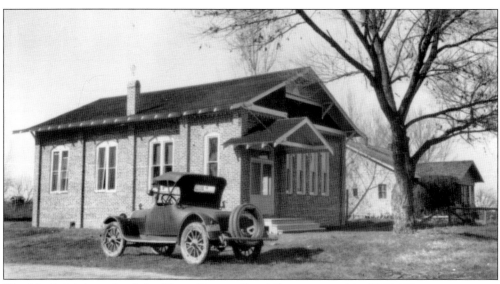

The Hardwick branch of the Kings County Free Library opened in 1938. The structure was converted from the Hardwick Methodist Church building. (Courtesy California State Library.)

The Hardwick Library had a staff of four, as shown in this photograph. (Courtesy California State Library.)

Walnuts were a major crop in the Hardwick area; this photograph shows a mechanized shaker operating on the van Beek ranch in the 1950s. Large branches were clutched by the padded mechanical arm and the entire tree shaken to cause the ripe walnuts to fall to the ground. The fallen walnuts were picked up by workers. The author can remember being paid 15¢ a bucket to pick up walnuts in 1967. (Photograph donated by Donna van Beek, courtesy Kings County Library.)

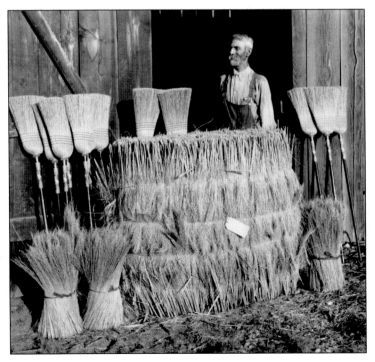

In the northwest corner of Kings County lies the Island District, so named because the Kings River divides for several miles before rejoining, creating a large section of land completely surrounded by the river. Daniel C. Starrett lived in the Island District and operated a blacksmith shop at Twenty-first and Fairfax Avenues. He also made brooms from cornstalks. Starrett is pictured in front of his shop in this undated photograph. (Courtesy Kings County Museum.)

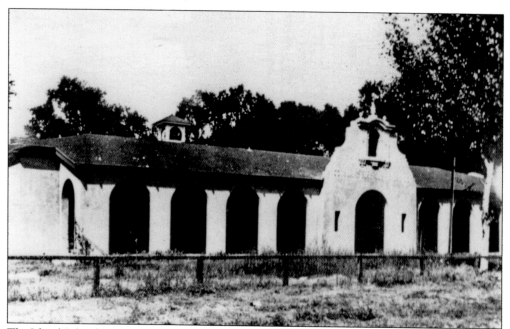

The Island School District was originally formed by Fresno County, because the Island District itself was part of Fresno County until 1919. It was part of Laton School District while in Fresno County and transferred to the Lemoore School District when brought into Kings County. The school building pictured here was built in 80 days in 1921. The school unionized with San Jose School in 1954, and a new campus was constructed in 1958. (Courtesy Kings County Museum.)

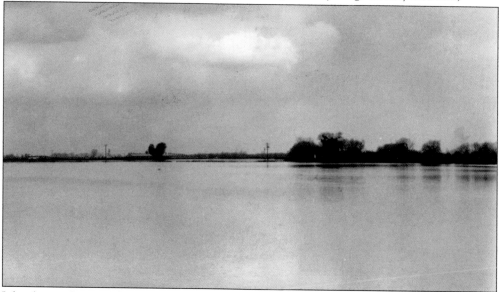

Like the residents of the Tulare Lake basin, the residents of the Island District live in an area subject to flooding. The 1969 flood caused the Kings River to overflow near Twenty-second and Elder Avenues, and Carl Anderson captured the flood on film. The Kings River channel is behind the trees in the background; in the foreground is flooded farmland. This photograph was taken in January 1969. (Photograph by Carl H. Anderson, courtesy USDA Natural Resources Conservation Service.)

The water level in the Kings River subsided, and water from the flooded areas began flowing back into the river channel. The Kings River can be seen between the closest trees and the line of trees in the background. Just in front of the two largest trees near the center of the photograph, the flowing water goes back into the river channel. The story of Kings County in the past has always involved the residents' relationship with water, and that is just as true today as it was 115 years ago, when Kings County was formed and named after the river that gave it life. (Photograph by Carl H. Anderson, courtesy USDA Natural Resources Conservation Service.)

BIBLIOGRAPHY

Arax, Mark and Rick Wartzman. *The King of California: J. G. Boswell and the Making of a Secret American Empire*. New York: Public Affairs/Perseus Books, 2003.

Armona American Revolution Bicentennial Committee. *The Armona Centennial 1876–1976, One Hundred Years of History*. Armona, CA: Armona American Revolution Bicentennial Committee, 1976.

Beebe, James W. *History of the Kettleman Hills*. Hanford, CA: Morning Hanford Journal, 1931.

Brown, J. L. *The Story of Kings County, California*. Hanford, CA: Hanford Morning Journal, 1941.

Brown, Robert R., and J. E. Richmond. *History of Kings County*. Hanford, CA: Arthur Hamilton Causton, 1940.

Clark, Jay, and Dorothy A. Mattos, eds. *The Kingdom of Kings: The History of Kings County, California*. Hanford, CA: The Kings-Hanford Kiwanis Club, 1992.

Corcoran Journal. Golden Jubilee Edition, 1964.

Gibson, Harold H. *History of Kings County Public Schools*. Hanford, CA: H. H. Gibson, 2004.

History of the Avenal Ranch: A Report to the Stockholders of the Avenal Land and Oil Company, 30th May, 1942. Unpublished manuscript, 1942.

Kings County Centennial Committee. *Kings County: A Pictorial History*. Hanford, CA: Kings County Centennial Committee, 1992.

Lemoore Centennial Committee. *Lemoore Centennial 1873–1973*. Lemoore, CA: Lemoore Centennial Committee, 1973.

Preston, William L. *Vanishing Landscapes: Land and Life in the Tulare Lake Basin*. Los Angeles: University of California Press, 1981.

Roberts, Robin Michael. Images of America: *Hanford*. Charleston, SC: Arcadia Publishing, 2005.

———. Images of America: *Hanford 1900–2000*. Charleston, SC: Arcadia Publishing, 2007.

Semas, Michael J. Postcard History Series: *Kings County*. Charleston, SC: Arcadia Publishing, 2005.

ACROSS AMERICA, PEOPLE ARE DISCOVERING SOMETHING WONDERFUL. THEIR HERITAGE.

Arcadia Publishing is the leading local history publisher in the United States. With more than 4,000 titles in print and hundreds of new titles released every year, Arcadia has extensive specialized experience chronicling the history of communities and celebrating America's hidden stories, bringing to life the people, places, and events from the past. To discover the history of other communities across the nation, please visit:

www.arcadiapublishing.com

Customized search tools allow you to find regional history books about the town where you grew up, the cities where your friends and family live, the town where your parents met, or even that retirement spot you've been dreaming about.